IMAGES
of America

ROGERS PARK

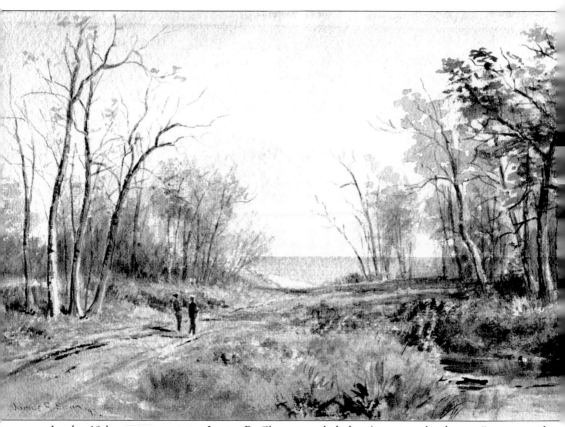

In the 19th century, painter Junius R. Sloan traveled the American landscape "in quest of beauty." Although Rogers Park was one of many stops, Sloan nevertheless captured the lakefront with the familiarity of an old friend, guiding his audience over the untamed shoreline, the white birches presiding over the dirt path, and the lake exuding a defiant peacefulness, yet ever showing signs of an undulating temper. The scene is unmistakably and recognizably Rogers Park. Dated 1893, the same year the burgeoning community left behind its days as a village and became part of the City of Chicago, this timeless painting is a testament not only to the artist's vision but also to the vision of dedicated residents of Rogers Park, who went on to fight—and win—a battle to preserve the lakefront as an accessible part of the neighborhood. To this day, the best way to a beach in Rogers Park is by foot. (Courtesy of Valparaiso University; created by Junius R. Sloan, 1827–1900. *Road to Lake, Rogers Park, Chicago, 1893.* Watercolor on paper, gift of Percy H. Sloan, Brauer Museum of Art, 53.01.333.)

On the cover: Perhaps more than any one place in Chicago's northernmost neighborhood, this Howard Street strip, east of the L and west of Greenview Avenue, is quintessentially Rogers Park. From its heyday as the party town border between Chicago and the very dry north suburbs, to its maturation as a thriving business district in the 1940s and 1950s shown on the cover, to the changing social landscape of the 1960s, to the economic blight of the 1970s, 1980s, and 1990s, Howard Street has proven to be a visceral window to the wondrous dynamism that is Rogers Park. (Courtesy of Rogers Park/West Ridge Historical Society.)

IMAGES
of America

ROGERS PARK

Jacque Day Archer and
Jamie Wirsbinski Santoro

ARCADIA
PUBLISHING

Published by Arcadia Publishing
Charleston, South Carolina

Printed in the United States of America

Library of Congress Catalog Card Number: 2006935467

For all general information contact Arcadia Publishing at:
Telephone 843-853-2070
Fax 843-853-0044
E-mail sales@arcadiapublishing.com
For customer service and orders:
Toll-Free 1-888-313-2665

Visit us on the Internet at www.arcadiapublishing.com

This book is dedicated with much affection to Mary Jo (Behrendt) Doyle, a founder and current executive director of the Rogers Park/West Ridge Historical Society. Mary Jo (left) plays on Jarvis Beach with her sister, Dorothy Ann, and brother, James "Chipper," who at age 14 declared that he wanted to be called Jim from then on. However, he forgot to respond unless people called him Chip. (Courtesy of Mary Jo Doyle.)

CONTENTS

Acknowledgments 6

Introduction 7

Foreword 9

1. The First Peoples 11

2. Life on the Ridge 17

3. Citizens of Chicago 29

4. The North Shore of Days Past 47

5. The Jazz Age 61

6. The Great Depression 77

7. Television and Apple Pie 95

8. Great Struggles, Great Strides 107

9. An Image of America 117

Index 126

ACKNOWLEDGMENTS

We first set foot inside the Rogers Park/West Ridge Historical Society (RP/WR HS) in January 2006. Our goal was to research this book. Suddenly we found ourselves working, digging through boxes of photographs, framing artwork, and hanging an exhibit, which launched amid a flurry of local celebrities and a network news camera. In the process we met new friends and found an indelible mentor—founder and executive director Mary Jo Doyle. She is the beacon who watches over the history of our area, and our most heartfelt acknowledgment extends to her. We would also like to thank the society's board of directors and volunteers who work so diligently to make Rogers Park's history available to the public.

Special thanks also go to the following individuals and organizations: to Cathie Bazzon of the Rogers Park Community Council for her support and encouragement throughout the project; to Sr. Ann Ida Gannon for her years of service to humanity and Aimee Brown and Dr. Elizabeth Myers of the Loyola University, Women and Leadership Archives; to the family of Alice Touhy McKinley (1878–1963), Brown University, Chicago History Museum, Julia Bachrach of the Chicago Park District, Joyce Shaw and Bruce Moffat of the Chicago Transit Authority, Blake Norton of the Cultural Heritage Center, Citizen Potawatomi Nation, Eden Juron Pearlman of the Evanston Historical Society, John Fitzgerald of the Howard Area Community Center, Kathy Young of Loyola University, Francis Tobin of the Rogers Park Community Action Network, Julie Lynch of the Sulzer Regional Library, and Valparasio University's Brauer Museum of Art for making their collections available to us; to Don Bryant, Kang Chiu, Dan Dooley, Jacquelyn Klein Fie, Jules Gershon, Sandy Goldman, Katy Hogan, Michael James, Ted Jindrich, the Kinsch family, Hershel Oliff, Marc Paschke, Chris Serb, Beverly Tatz, Richard Tillstrom, Karen Tipp, Peter Winninger Jr., and John J. Zender Jr. for sharing stories and photographs; to Charlie Didrickson, John Mikrut, and Martin J. Schmidt whose photography enriches our work; to James Slate, whose artistic eye proved invaluable amidst a sea of images; to Doug Brooks, Mary Jo Doyle, David J. Hogan, Robert Rodriguez, and Michael Staples for lending a critical eye to the text; and to John Pearson and Melissa Basilone at Arcadia Publishing, who made it all happen in the first place.

INTRODUCTION

On a map, Rogers Park presides over Chicago like a sentry, extending further north than any other point in the city. In many ways, our physical position is a metaphor for our determination to reach higher, our openness to new ideas, our outstretched arms to anyone wishing to enter. The history of Rogers Park is the history of America.

Through the centuries, strong winds have blown in and out of the patch of Earth that became our neighborhood—winds that brought the peoples of the Potawatomi, Ottawa, and Chippewa Nations to live in camps along the lakeshore, winds that drove New America westward into these lands, pushing our Native American brothers and sisters away. In the 1830s, when Chicago was still a fledgling village, Philip McGregor Rogers followed the winds from the east in search of economic opportunity. More came—Irish and English, Luxembourgers and Germans. They cultivated the soil, built houses and farms, grew lettuce and celery and cabbage. Through the 1840s and 1850s, this small immigrant farming settlement, 10 miles north of today's downtown Chicago, carved out a unique identity.

The winds came again, carrying an opportunistic veteran of the Civil War named Patrick Leonard Touhy into the community's marshy soil and mud-soaked roads. As the Great Chicago Fire of 1871 destroyed the city, the bombastic Touhy turned real estate interests northward. And in 1878 when he proposed that their village be named for his long-deceased father-in-law, Philip Rogers, he likely did so in the same spirit as his downtown friends whose boastful rhetoric earned Chicago its nickname—the Windy City.

By the late 19th century, Rogers Park was in demand. Part of the grand North Shore, its lakeside wealth and affluence and vital independent economy made it an attractive prospect for a metropolis looking to expand. In 1893, after only a decade and a half as an independent village, it became part of Chicago.

Rounding the corner of the century, Rogers Park roared with the 1920s, sank with the Depression, galvanized during the world wars, ate TV dinners in the 1950s, protested during the 1960s. In the latter part of the 20th century, it opened its doors to people of all ethnicities, religions, and creeds, taking on new life as one of the most ethnically, economically, and socially diverse communities in the nation.

As we grow and change, the prevailing winds carry this message—we are first Rogers Park, a community of the world. After that, we are a neighborhood of Chicago.

Rogers Park stretches from Lake Michigan on the east to Ridge Boulevard on the west and from Devon Avenue on the south to the Evanston city limits on the north. But many who live in the area west of Ridge Boulevard will still say with confidence that they are from Rogers Park. Although it is a convincing colloquial identifier, Rogers Park's western neighbor's true name is West Ridge. The confusion is understandable—before the division of the neighborhoods, the entire area was known as "Rogers Ridge" after its namesake, Philip McGregor Rogers, who owned land on both sides of today's dividing line, and an area within West Ridge is commonly called "West Rogers Park."

FOREWORD

The November waves crashed into the beach, driving the relentlessly frigid air in gusts that rocked into me steadily, like a pulse, as I stood on the southwest corner of Rogers Avenue—my corner—looking north. I thought, "I live on Indian Boundary Line." A surreal sensation moved through my body. Nearly two centuries ago, representatives of the Council of Three Fires (united tribes of Ottawa, Ojibwa, and Potawatomi) met with federal officials, one of them William Clark of the Lewis and Clark expedition, to sign the Treaty of St. Louis (1816). The treaty transformed this dirt path, now a Chicago street on which I stood, into an invisible fence, separating lands that still belonged to the Native Americans from the property of New America, a line between a time when freedom required no definition and a future of boundaries and ownership. I looked north, and as I felt the ghosts of my Native American brethren studying me from across the way, I grabbed a young man walking past me in the night. "This is where it started." I pointed to the sidewalk, then upward to the Rogers Avenue street sign. "The Indian Boundary was right here, right where we stand." I stomped for emphasis. "Now it's named for the first white guy to buy land here, Philip Rogers." The young man seemed interested. "Yeah," he said, his eyes coming alive a little bit, "Rogers Park." And as his girlfriend dragged him away, I thought, "There's a story here."

—Jacque Day Archer

"Want to write a book on Rogers Park?" she asked. "Absolutely!" I replied in the next instant, no time wasted, no need to think it through. I knew this was the book I wanted to write, had always wanted to write. Immediately I was carried back 25 years to my first day in Rogers Park. I had gotten off the L at Morse Avenue, skipped down the stairs, and pushed past the doors of the station onto the street, and then I stopped, transfixed: a young Nigerian woman, in brightly colored African dress, ran to catch the approaching train, a Mexican man wove through the sidewalk's traffic with his bicycle cart of cold treats, across the street, a mix of children, black, brown, white, walked to school. I stood spellbound, utterly absorbed. Here, I thought, were complexities and contradictions and space enough to stretch and grow. Here the neighborhood feels larger than the world. Here is home. "When do we start?" I asked.

—Jamie Wirsbinski Santoro

Contact the authors at rogersparkbook@gmail.com.

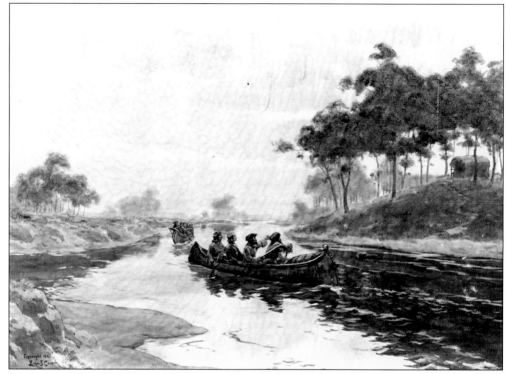

Jesuit missionary Fr. Jacques Marquette was probably the first white man to visit the Rogers Park area. Legend says that he and two companions of French–Native American ancestry camped near the corner of Devon Avenue and Sheridan Road, near the site of Loyola University Chicago's Piper Hall, in late October 1674. The group was en route to present-day Starved Rock where Father Marquette planned to establish a mission for the Illinois Indians. (Courtesy of Library of Congress, LC-USZ62-116498.)

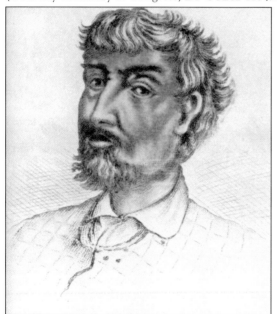

When the French-speaking African American from Sainte-Domingue (Haiti), Jean Baptiste Pointe Du Sable, built the first permanent settlement at the mouth of the Chicago River in the 1770s, he carved his name in history as the founder of "Checagou." He ran a trading post, married Catherine, a Potawatomi, and by many accounts set the course for a friendly coexistence between pioneers and the land's first peoples. It was not to last. (Courtesy of Cultural Heritage Center, Citizen Potawatomi Nation; illustration by Raoul Yarin.)

One

THE FIRST PEOPLES

While we were being pushed westward another tidal wave of pale-faced humanity came moving against us from the south, driving before it the red man, like buffaloes before the prairie on fire.

—Simon Pokagon, chief of the Pokagon band of the Potawatomi, 1899

A variety of native peoples, including the Illinois and the Miami, lived in the area now known as Rogers Park, but by about 1760, the Potawatomi called this area home. They built semi-permanent villages near the lakeshore and raised crops, hunted, fished, and gathered food. The Potawatomi welcomed the French fur traders and formed close ties with them. The two groups intermarried, produced a growing number of mixed-blood children, and formed a thriving, multi-racial community.

The dissolution of this community began slowly. The 1795 Treaty of Greenville was the first in a series of treaties that gradually stripped the Potawatomi of most of their land. In 1816, an old Native American trail beginning at present-day Rogers Avenue Beach and Park became the North Indian Boundary Line. Later renamed Rogers Avenue, the street slices through the heart of today's Rogers Park, a vestige of a diagonal wound that separated Native American lands from America's claims. By 1833, the Treaty of Chicago dealt the final blow, and the federal government seized all Native American lands in Illinois. Many left Chicago with dignity to face the long walk to the Mississippi River, but some remained as squatters where they once lived freely.

Meanwhile in Watertown, New York, young Irishman Philip McGregor Rogers set his sights on the "Great Northwest," a wild, uncultivated land of which he heard tales of savages who once roamed, but now contained only endless opportunities for a young man of enterprising spirit. Encouraged by these stories, 18- to 20-year-old Rogers arrived in Chicago sometime in the 1830s and built his homestead alongside an old glacial ridge that was also a well-used, north–south thoroughfare originating with Great Lakes–region Native Americans and later a military, trade, and stage coach route for soldiers, explorers, and settlers known as the Green Bay Trail. Rogers is on record as the first landowner in the area that would come to bear his name.

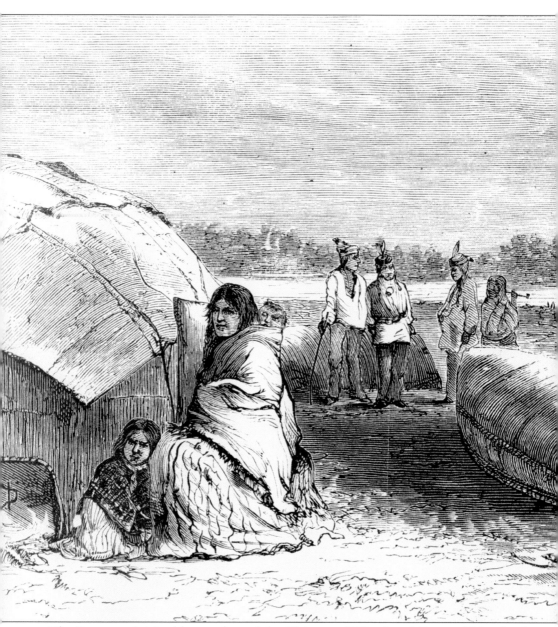

The Potawatomi, joined by members of the Chippewa (Ojibwe) and Ottawa (Odawa) tribes, lived by the lakeshore in domed dwellings, framed with slender green saplings and covered with pliable birch bark, which was found in abundance in the area. Maps from the early 1800s indicate the presence of three villages in the area—one near the present-day intersection of Rogers Avenue and Greenview Avenue, another near Rogers Avenue and Clark Street, and

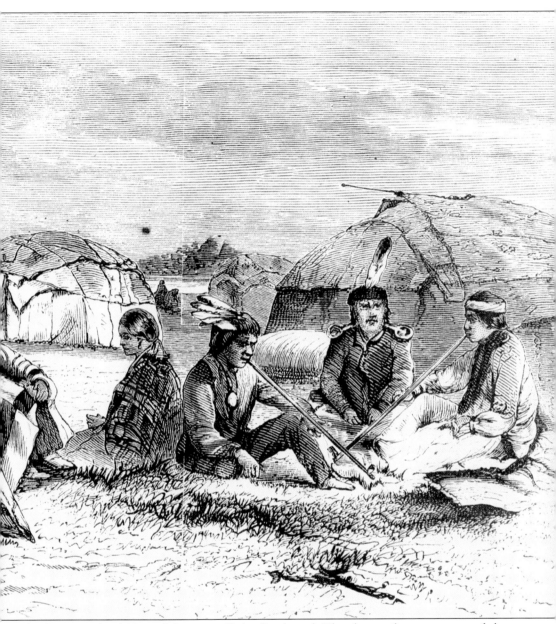

a third just south of Howard Street on Ridge Boulevard. The three tribes, once part of the powerful Anishinabe Nation, splintered in the wake of America's expansion, which drove them from the East Coast. By the 1800s, the stress of oppression and disease had greatly diminished their numbers. (Courtesy of Library of Congress, LC-USZ62-106105.)

Called "the most momentous real estate transaction in the history of Chicago," the 1795 Treaty of Greenville marked the first government land "purchase" in Illinois—six square miles at the mouth of the Chicago River. In the years to follow, the area was peopled by traders and bore little interest to the federal authorities until the 1803 Louisiana Purchase doubled the size of the country. Fort Dearborn was erected that same year. (Courtesy of Chicago History Museum, ICHi-03039; created by C. E. Petford.)

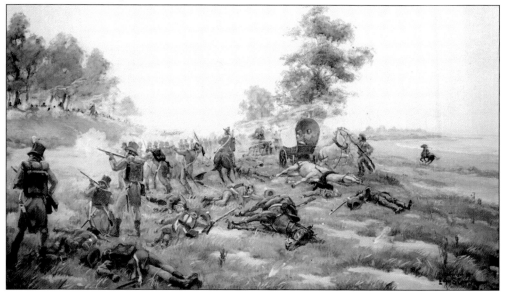

During the War of 1812, many Native Americans sided with the British, posing a threat to Fort Dearborn. As the fort's 148 men, women, and children fled, 500 Potawatomi and Miami warriors descended, killing half, capturing the rest, and burning the fort to the ground. The Battle of Fort Dearborn was, by British accounts, a decisive victory. (Courtesy of Chicago History Museum, DN-0009354; painted by Edgar S. Cameron.)

The defeat of the British in 1816 brought a relative, if not entirely comfortable, stability to the region. The United States Indian Commissioners negotiated the Treaty of St. Louis, which ceded a 20-mile-wide tract of land extending southwest from points 10 miles north and 10 miles south of Chicago, connecting with the Mississippi River. Rogers Avenue is the northern boundary of this tract and was previously called North Indian Boundary Line. (Courtesy of Library of Congress.)

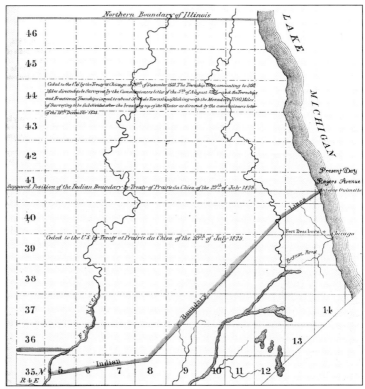

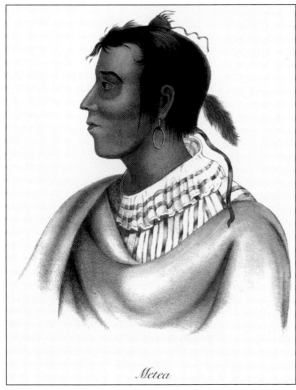

Metea

A great orator among his people, Chief Metea admonished the delegation at the first Treaty of Chicago, signed in 1821: "Our country was given to us by the Great Spirit, who gave it to us to hunt upon, to make our cornfields upon, to live upon and to make down our beds upon when we die, and He would never forgive us should we bargain it away. . . . We are growing uneasy. What lands you have you can retain forever, but we shall sell no more. . . . If we had more land, you should get more. But our land has been wasting away ever since the white people became our neighbors and we now have hardly enough left to cover the bones of our tribe." (Courtesy of Cultural Heritage Center, Citizen Potawatomi Nation.)

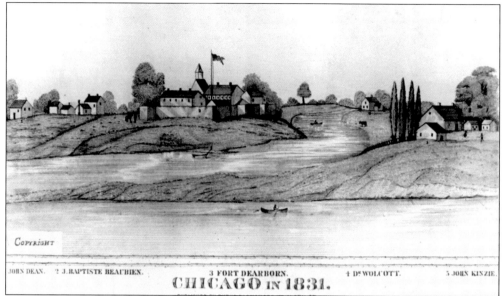

JOHN DEAN. 2 J.BAPTISTE BEAUBIEN. 3 FORT DEARBORN. 4 D? WOLCOTT. 5 JOHN KINZIE.

CHICAGO IN 1831.

Fort Dearborn was rebuilt in 1816 but abandoned in 1823. Since the area's traders, trappers, and tribes got along without incident, the fort was considered unnecessary. But a new crop of settlers seeking land and fortune arrived, and they were suspicious of all Native Americans, especially the Sauk leader Chief Black Hawk, who vowed to reclaim his ancestral lands. The fort was regarrisoned in 1828. (Courtesy of Library of Congress, LC-USZ62-56482.)

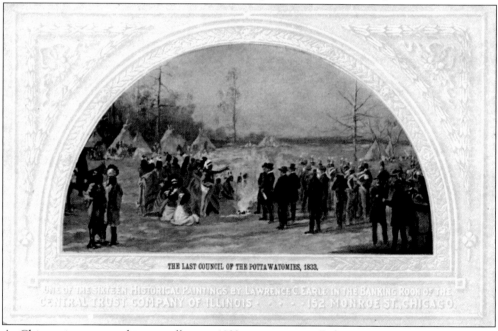

THE LAST COUNCIL OF THE POTTAWATOMIES, 1833.

ONE OF THE SIXTEEN HISTORICAL PAINTINGS BY LAWRENCE C EARLE IN THE BANKING ROOM OF THE
CENTRAL TRUST COMPANY OF ILLINOIS · · · · 152 MONROE ST. CHICAGO.

As Chicago incorporated into a village in 1833, commissioner Robert C. V. Owen negotiated the final cession of Illinois land, the last council of the Potawatomi. Historian Jacqueline Peterson described the scene: "Painted in the colors of death, they made their final tour through the streets already covering the ancient trails and fields, dancing their way out of vision, their shrieks sticking in the American's ears." (Courtesy of Donald Bryant collection; created by Lawrence C. Earle.)

Two

LIFE ON THE RIDGE

Go West, young man, and grow up with the country.

—John B. B. Soule, *Terre Haute Express*, 1851

Philip McGregor Rogers was one of many young Americans to journey west in the early 1830s. Enticed by promises of wide-open spaces, inexpensive land with rich soil, and even gold, Rogers traveled westward with his brothers, settling for the winter north of the new village of Chicago. At the weather's break, while his brothers continued west, Rogers stayed back, carved out a living as a charcoal burner and vegetable grower and began to acquire property in present-day Lakeview, four miles north of today's Chicago Loop but still five miles south of the future Rogers Park. By the time of his marriage to the landowning widow Mary Masterson Hickey, he had already amassed numerous land holdings himself. He set his sights further north.

In all likelihood, Rogers staked his claims in present-day Rogers Park early, settling before the lands came up for sale. Others probably did the same, like John Zender who, according to local legend, built the first structure in the area—a tavern, around 1836—although no official records exist. Rogers's first area purchase from the government occurred in 1841, and although history calls Rogers the region's founding landowner, at least one other purchase was made in the area on the exact same day. It was not the Oklahoma land rush, but the same notion prevailed—land was in demand, and people were waiting in line.

It is wholly possible that Rogers's son-in-law, Patrick Leonard Touhy, a developer and self-promoter to rival P. T. Barnum, spun the area's origins in Rogers's direction to keep it in the family. When it came time to incorporate as a village, it was Touhy who proposed the name Rogers Park. His plan stuck. The Village of Rogers Park came to be in 1878.

The benefits of the transcontinental railroad completed in 1869, together with the railroad building boom, bore fruit for the little village by the late 1870s. The train linked Rogers Park with Chicago and beyond and ushered in an era of growth. Businesses developed near the tracks, and within a few years, the two blocks between Clark Street and Ravenswood Avenue and between Lunt and Estes Avenues became the central business district of the area.

In 1833, Illinois was part of the "Old Northwest," and Chicago was a frontier town of 350 people. That changed quickly. Fueled by westward expansion, the village's population grew by 10 times within the next few years. In 1837, Chicago incorporated as a city, and by then, the open land to the north had already attracted the most enterprising of immigrants, among them a Prussian named John Zender and an Irishman named Philip Rogers. (Courtesy of Library of Congress, LC-USZ62-56484.)

According to the *Chicago Tribune*, 1900, "When Rogers came west from Watertown, NY, it was prairie and woodland, trackless except for Indian trails and deer runs and a single road." Young Rogers married Mary Masterson Hickey, combining her land assets with his own. They had two children, Philip Jr. and Catherine, who later became the grand dame of Rogers Park as the wife of primary developer Patrick Touhy. (Courtesy of Sulzer Regional Library, Historical Room, Chicago Public Library.)

"Rogers Park land was the last thing that anyone wanted," a news clipping claimed in 1926. Rogers secured the parcel between what is now Touhy Avenue, Western Avenue, Ridge Boulevard, and Morse Avenue for $1.25 an acre. Having no pictures of Rogers, his family displayed a portrait of English actor Sir Henry Irving in their home, because of the famed thespian's resemblance to the elder Rogers.

No photographs exist of the modest home and tavern Zender built around 1836, the earliest known structure along the popular Green Bay Trail, but this photograph of the Murphy farmhouse captures the look of the day. Built in 1840 on the northwest corner of Rogers Avenue and Clark Street, it remained there until the 1930s. (Courtesy of RP/WR HS.)

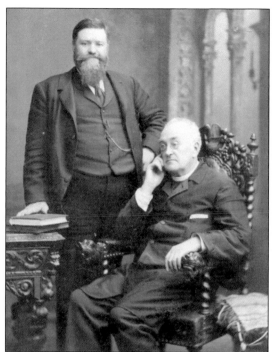

Philip Rogers died in 1856, at age 44 and would not live to meet the man who immortalized his name. Patrick Touhy (standing), an enterprising Irish-Catholic immigrant and a Civil War veteran, married Rogers's daughter, Catherine, in 1865, acquiring her portion of the estate. He was in business with Catherine's brother, Philip Rogers Jr., until the young man's untimely death in 1869. All assets went to Touhy. (Courtesy of Alice Touhy McKinley collection, 1878–1963.)

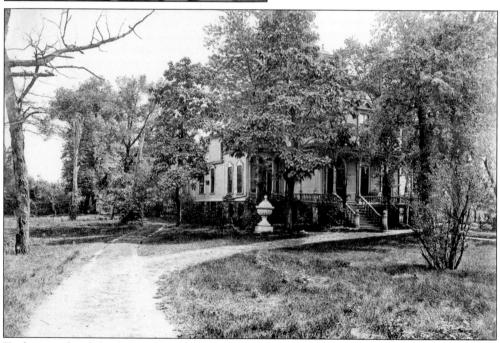

Touhy completed this home, "the Oaks," in 1871, and in 1873, sold interests in his landholdings to Paul and George Pratt, John V. Farwell, Luther L. Greenleaf, Stephen P. Lunt, George Estes, and Charles H. Morse. They established the Rogers Park Building and Land Company. Patrick and Catherine raised seven children at the Oaks. Touhy's development efforts were slow going at first, until a fire—legendarily blamed on another Irish Catholic and her cow—changed the course of history. (Courtesy of Alice Touhy McKinley collection, 1878–1963.)

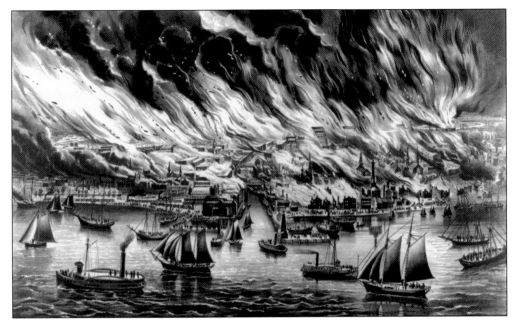

On October 8, 1871, a fire began in a shed at 137 DeKoven Street in Chicago, quickly spreading into a conflagration that ravaged the city for two days. It destroyed a four-mile area, including all of the downtown and drove a fleeing populace north into the Lincoln Park area. The blaze finally subsided near Fullerton Avenue. The Great Chicago Fire prompted growing interest in Touhy's lands, which were untouched and far north of the city. (Courtesy of Library of Congress, LC-USZ62-14092.)

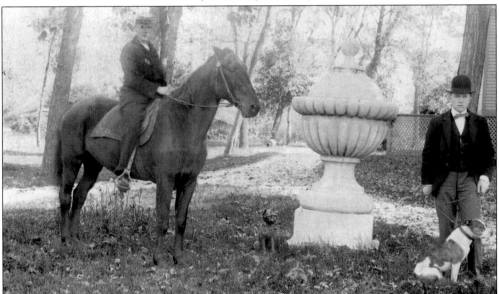

An ornamental stone from Chicago's old courthouse, a remnant from the Great Chicago Fire, decorates the Touhy lawn. A well-connected man who regularly entertained such high rollers as Mayor Carter Harrison and William Tecumseh Sherman, Touhy was the driving force behind the incorporation of the Village of Rogers Park in 1878. The Touhys lived in separate homes for the last 15 years of their marriage, until Patrick's death in 1911. (Courtesy of Alice Touhy McKinley collection, 1878–1963.)

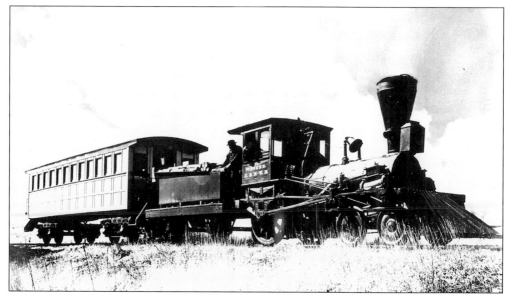

Railroads were key to the expansion and development of Rogers Park. In 1885, the Chicago, Milwaukee and St. Paul Railway Company completed a line through Rogers Park. Today the Chicago Transit Authority's Red Line trains follow these tracks. (Courtesy of Lake County Discovery Museum, Wauconda.)

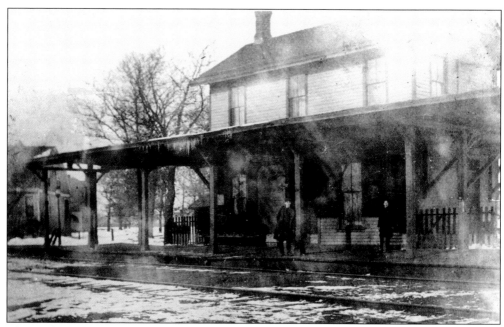

The Birchwood Depot was one stop on this line. Built in 1886, it was located on Bryan Avenue (now Jarvis Avenue) just east of Ashland Avenue, near the site of the present Jarvis elevated train station. The Birchwood Depot commemorated the birch forest that once occupied the area. Other stations on this line included Hayes (Loyola) and Rogers Park (Morse). The Howard Station was added years later in 1908 by the Northwestern Elevated Railroad, which operated on the St. Paul tracks. (Courtesy of RP/WR HS.)

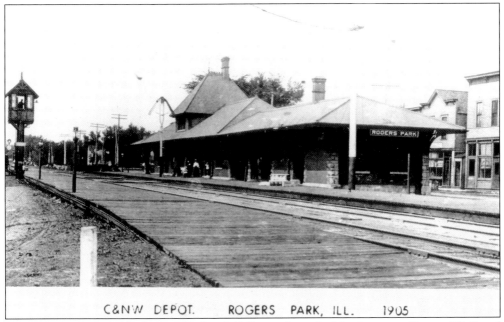

C&NW DEPOT. ROGERS PARK, ILL. 1905

The Chicago and North Western Railroad (different from the Northwestern Elevated Railroad on page 22) completed a route through the area in 1873 and opened a depot near Greenleaf and Ravenswood Avenues. A business district sprung up immediately, and for a short time, the two blocks on Ravenswood Avenue from Lunt Avenue to Estes Avenue were the hub of activity in Rogers Park. The present-day Metra line runs along these tracks. (Courtesy of RP/WR HS.)

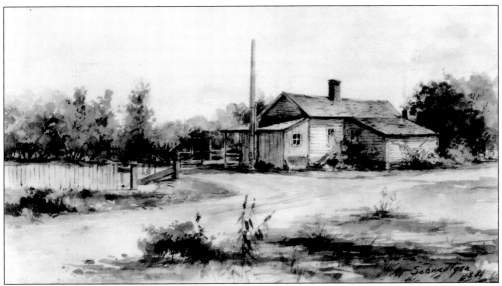

This tollgate was erected in 1869, at the corner of the North Clark Highway (Clark Street) and North Indian Boundary Line (Rogers Avenue) and was one of three tollgates along the route that required payment to pass through. All were strategically placed near cemeteries—Graceland, Rosehill, and Calvary—"where tribute was levied on the long processions that daily passed," wrote S. Rogers Touhy. The tollgates were abolished in the late 1880s. (Courtesy of Chicago Transit Authority.)

23

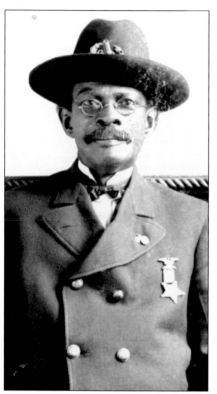

John William Pollard was born in 1846 in Virginia, the son of free black yeoman farmers. At eight, he was sent to live in Kansas because his mother feared a "rash of incidents in which children of free blacks were kidnapped and sold into bondage by proslavery zealots." In 1862, in the midst of the Civil War, he joined the Second Colored Kansas Regiment. Following the war he set his sights on a law degree at Ohio's Oberlin College, but a bout with smallpox interrupted his aspirations. Having learned the barber's trade from a white man, he polished his skills and quickly became a master barber. He and his wife Amanda Hughes, a woman of African American, Sioux, and French lineage, moved to Rogers Park in 1886 to raise their eight children. "The Pollards were proud of their racial heritage, to be sure," wrote John M. Carroll in *Fritz Pollard*, "but given the prevailing prejudices of the time may have realized their children could encounter fewer racial restrictions and enjoy greater educational advantages in Rogers Park." (Courtesy of RP/WR HS.)

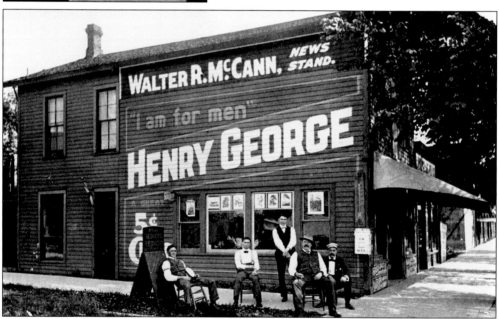

Walter R. McCann is seated second from right at his newspaper store on Ravenswood Avenue around 1890. In 1897, McCann became one of many people in the country to sight a flying airship, six years before Kitty Hawk: "I saw a strange looking object in the sky coming from the south. It looked like a big cigar." Allegedly, McCann took a picture of the object. The *Chicago Tribune* declared the photograph "genuine and not a fake." (Courtesy of RP/WR HS.)

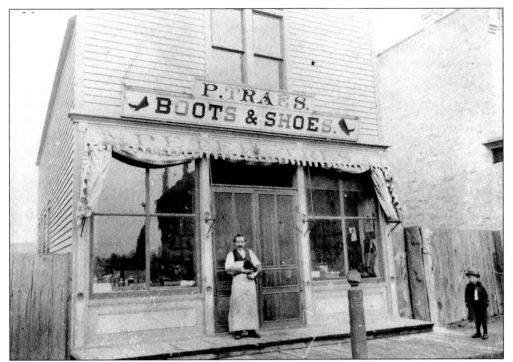

Cobbler Peter Tres, who spells his name two different ways on the same storefront, stands on the front porch of his shoe shop. The wood siding and sidewalks date the building prior to 1894, when a major fire destroyed much of the Clark Street business district, prompting new construction of brick and mortar. (Courtesy of RP/WR HS.)

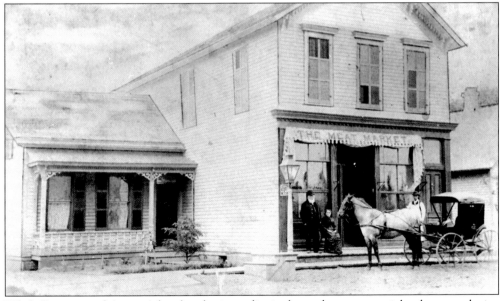

While Ravenswood Avenue's bustling business district housed narrow specialty shops conducive to train travelers, like a cigar store and barbershop, Clark Street's more spacious stores served the everyday needs of locals. In this building combination, around 1890, the Meat Market stands dominant to the office of physician Dr. W. D. Clark. (Courtesy of RP/WR HS.)

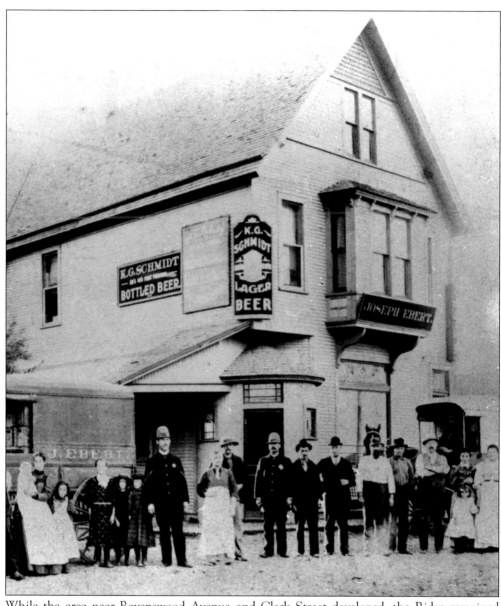

While the area near Ravenswood Avenue and Clark Street developed, the Ridge remained relatively rural. The community *op der Rëtsch* (up on Ridge) had been settled during Rogers's time—the mid 1840s—and consisted primarily of German and Luxembourger farmers, along with a handful of other new immigrants. They arrived seeking the traditional agrarian life that they had left behind in their home countries. Most cultivated vegetables for the Chicago market, while a few found opportunities as laborers, artisans, and saloon keepers. They also constructed a rich social life that found its focus in St. Henry's parish (built in 1851 along the Ridge) and the local inns and taverns where they danced, played cards, ate, and drank beer. Their countrified lifestyle contrasted sharply with the new inhabitants of Rogers Park, fueling a growing distinction between those on the Ridge and those in the new business area along Ravenswood Avenue. (Courtesy of RP/WR HS.)

Residents of the Ridge had a strong immigrant identity. A cohesive community with common traditions, customs, and language. They resented the taxes they had to pay for local improvements to the developing Rogers Park area. To protect themselves from these charges, they incorporated as the Village of West Ridge in 1890. (Courtesy of RP/WR HS.)

Temperance and Sunday-closing laws also encouraged the split between the two communities. For residents of West Ridge, it was the custom to meet friends and fellow workers on Saturday afternoon and Sundays for leisure and pleasure, and they regarded these new laws as an attack on their personal liberties and ways of life. This incited growing class and ethnic conflict between Rogers Park and West Ridge. (Courtesy of RP/WR HS.)

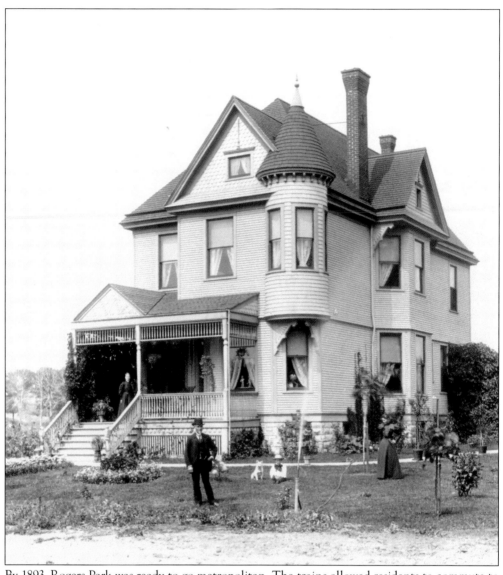

By 1893, Rogers Park was ready to go metropolitan. The trains allowed residents to commute to professional and managerial positions downtown. An upper-middle class began to take shape that was different from their working-class counterparts of West Ridge. This new class had money and was eager for graded streets and paved sidewalks. Rogers Park was quickly becoming an affluent suburban subdivision of Chicago. On April 4, 1893, less than a month before the grand opening of Chicago's World's Columbian Exposition, the village voted in favor of annexation to the City of Chicago, expanding Chicago's city limits just in time for the World's Fair, and affording Rogers Park the benefits of a flourishing city economy. In a turn of irony (or perhaps coincidence), West Ridge annexed to Chicago on the same day. The two communities, once united by the "pulse" of the Ridge, then divided by it, were siblings once again. They would continue thereafter to grow in very different directions. (Courtesy of RP/WR HS.)

Three

CITIZENS OF CHICAGO

When Chicago decided to take Rogers Park under her protective wings (in 1893) she made a wise move. By annexation, Rogers Park's two schools, which are ranked among the best in the country, became city property. And, these are perhaps the greatest acquisitions gained by the transfer of title of the village on the north shore to the city government.

—*Chicago Evening Post*, February 23, 1894

In 1893, Rogers Park had two competing railroads, with over 80 trains passing through daily. An abundant supply of filtered water, two superior schools, five church organizations and a thriving business district served 3,500 residents. Annexation promised still greater gains, and Rogers Parkers looked ahead to a future as part of the Windy City.

The year 1893 was big, not just for Rogers Park but for a Chicago attempting to gain status as a world-class metropolis and to prove it had risen triumphantly from the ashes of the Great Fire. The addition of Rogers Park expanded Chicago's city limits in time for the World's Columbian Exposition, which attracted 27 million visitors from across the globe. Many Rogers Parkers participated in, attended, or worked at the exposition.

As the nation struggled through an economic depression, the "Gay Nineties" marked a crucial development era for post-annexation Rogers Park, which faced the challenge of adjusting to its new status. Sometimes the changes were welcome, such as telephone service and electricity. Yet other changes meant the death of unique beauties of the area—Rogers Park's white birch forest died off, poisoned by ground seepage following the expansion of the city's sewer system.

One thing stood true, while the assimilation into the city succeeded amid bumps in the path, Rogers Park's already firmly cemented community identity would stubbornly prevail into the 20th century.

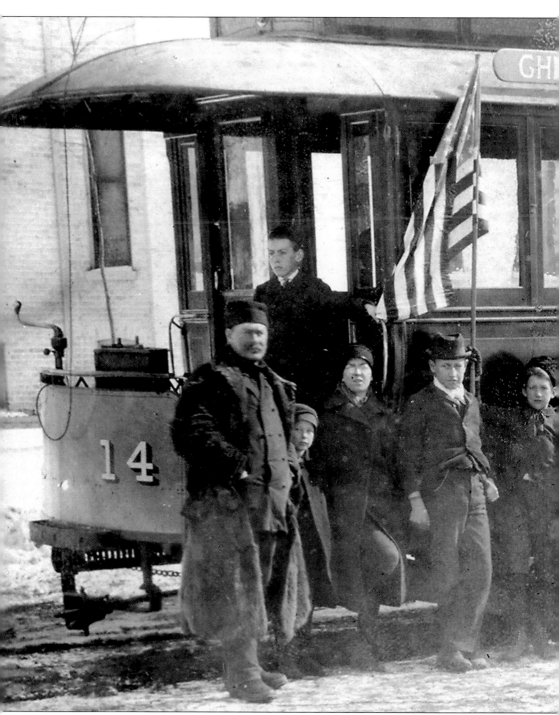

Shortly after annexation, the North Chicago Street Railway Company extended its Clark Street car service to Rogers Park, but demanded that Rogers Park residents pay another fare upon crossing Graceland Avenue (now Irving Park). The people of Rogers Park rebelled, claiming that as taxpaying citizens of Chicago, they were entitled to the service penalty-free. Armed with transfers of their own making, a large group of residents boarded a southbound Clark Street car.

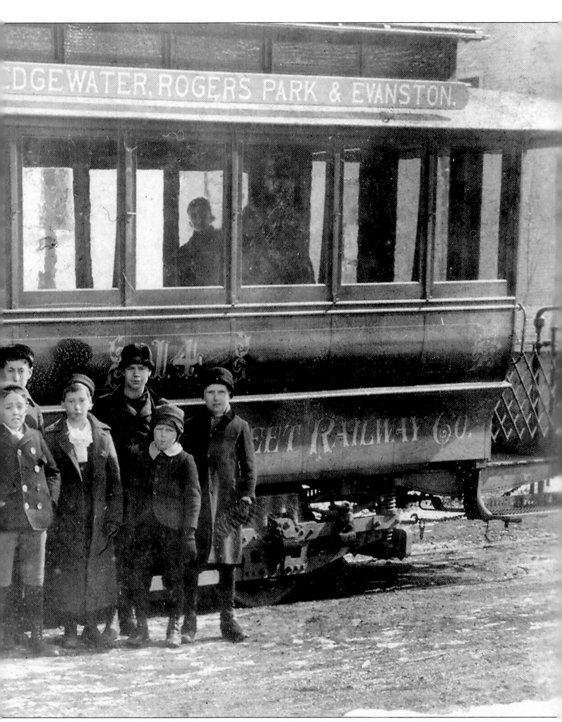

At Graceland Avenue they refused to pay an extra fare and instead presented their homemade transfers. A standoff ensued, but the Rogers Parkers stood firm. Eventually the crew relented, and the passengers rode downtown without paying the extra fare. All across the north side, people celebrated the victory by hoisting flags and banners. (Courtesy of Evanston Historical Society; photograph by J. D. Toloff.)

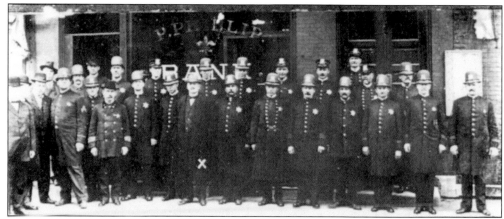

As promised, annexation brought about the development of city services. When Rogers Park was a village, three policemen served to protect the citizens. After annexation, 18 were assigned to the area. These men returned lost children, gave directions to strangers, and stopped runaway horses. The few arrests they made were for disorderly conduct, drunkenness, or vagrancy. (Courtesy of RP/WR HS.)

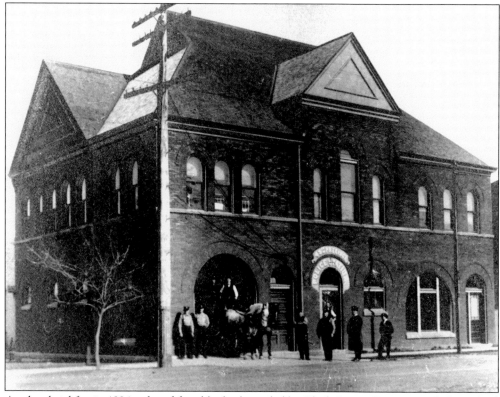

A substabtial fire in 1894 reduced four blocks, bounded by Clark Street, Ravenswood, Greenleaf, and Estes Avenues, to ashes. Cleanup and rebuilding took several years, but in the same spirit that followed Chicago's Great Fire, the business district rebounded with great improvements. In the late 1890s, the combined headquarters of the Rogers Park Town Hall, including the community's police and fire departments, was built at the southeast corner of Estes Avenue and Clark Street. (Courtesy of RP/WR HS.)

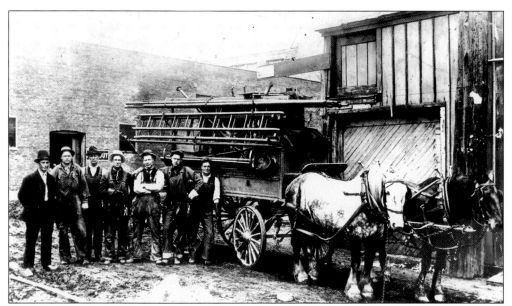

Rogers Park's annexation to Chicago brought city services to the community, including gas, water, electricity, connection to the main sewer system, street lamps, fire hydrants, paved sidewalks, and telephones. These Chicago Telephone Company employees, installing lines in Rogers Park about 1900, are working from a horse-drawn truck. In the coming decade, as the automotive industry gained stride, gasoline overtook the horse as the source of power for trucks. (Courtesy of RP/WR HS.)

In 1900, the Rogers Park Post Office opened its doors on the northeast corner of Greenleaf Avenue and Clark Street, close by the Chicago and North Western line. The location was strategic, as mail was now moved by train. The move from stagecoach mail to railway mail was credited to Chicago postal administrator George B. Armstrong in 1864, although William A. Davis, assistant postmaster in St. Joseph, Missouri, championed the transition a bit earlier. (Courtesy of RP/WR HS.)

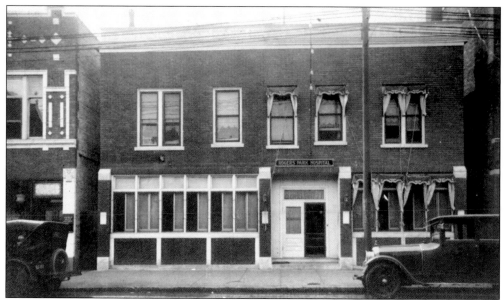

In 1881, an outbreak of smallpox in Chicago left several thousand dead. In 1891, bronchitis and typhoid fever swept the city. Many of these outbreaks were due to overcrowding, poor sanitation, and infected water supplies. Smaller hospitals, like this one in Rogers Park, served the neighborhood's sick. As the larger metropolitan hospitals began to offer more state-of-the-art care, smaller neighborhood hospitals phased out. (Courtesy of RP/WR HS.)

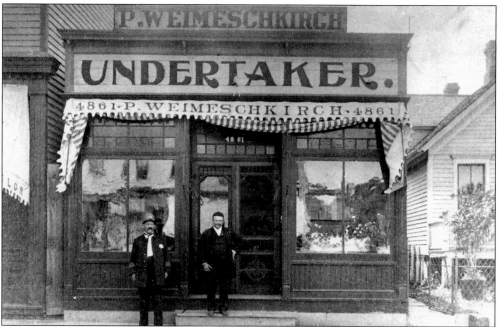

The constancy of death made undertaking a good business for the Weimeschkirch family. Their small storefront, at 4861 Clark Street (now 7066 North Clark Street), was established in 1888 and catered to the funeral and burial needs of Rogers Park residents for almost 100 years. They provided embalming services, caskets, and a multi-functional ambulance/hearse. Rose Weimeschkirch was the first licensed woman embalmer in Illinois. (Courtesy of RP/WR HS.)

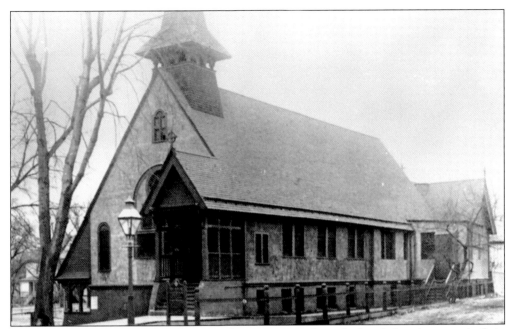

As the population of Rogers Park grew, religious activity flourished and churches were built in increasing numbers throughout the area. Known primarily as an Irish Catholic community, Rogers Park has always supported a variety of traditions. One of the first churches in the area was the Episcopalian St. Paul's Church by-the-Lake, built in 1886 on Lunt Avenue, just east of Clark Street. (Courtesy of RP/WR HS.)

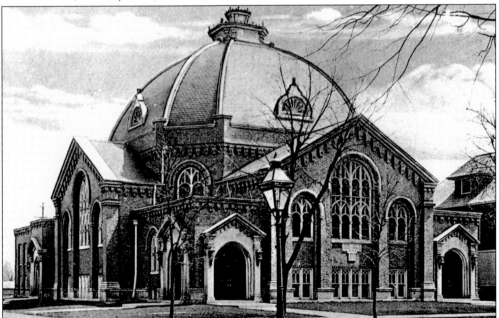

Within 20 years, the simple construction of the area's first churches gave way to fabulous, ornate structures designed by up-and-coming Chicago architects. The Rogers Park Congregational Church (now the United Church of Rogers Park), with its majestic dome and Renaissance styling, was one such structure. (Courtesy of RP/WR HS.)

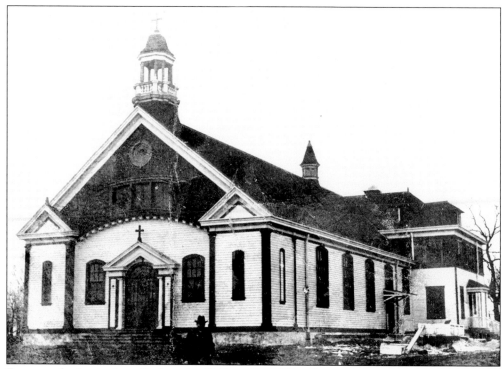

For years the Jesuits from St. Ignatius College (1076 West Roosevelt Road) served the needs of the many Catholic immigrants from Germany and Ireland on Chicago's near-west side, but these families had now risen from their working-class beginnings to join the middle-class and moved north in search of better neighborhoods like Rogers Park. In 1906, the Jesuits decided to follow suit. They purchased a tract of land along Lake Michigan from the Chicago, Milwaukee and St. Paul Railway and built St. Ignatius Catholic Church (above). Dumbach Hall (below), home to Loyola Academy, a high school meant to serve the growing north side, followed in 1908. In 1909, St. Ignatius College was rechartered as Loyola University. (Above, courtesy of RP/WR HS; below, courtesy of Loyola University Chicago Archives.)

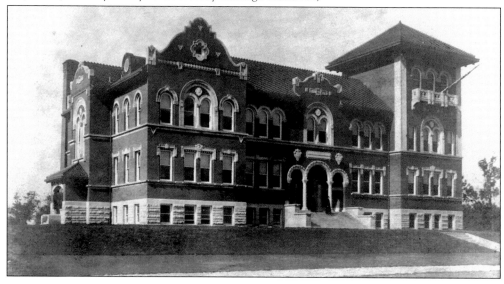

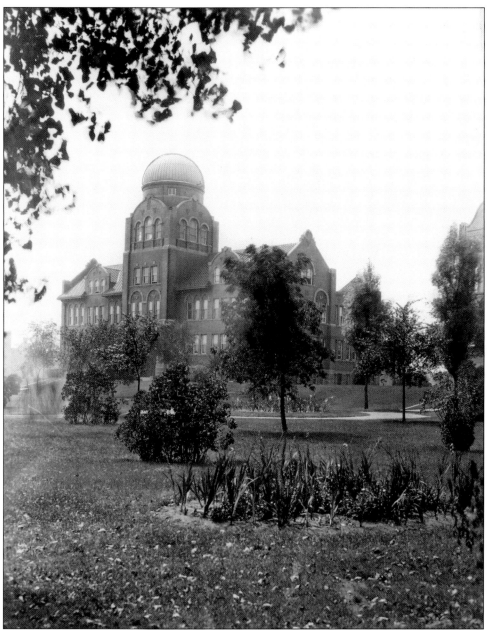

With the construction of additional buildings, like the green-domed, mission-style Cudahy Science Hall, built in 1912, college classes gradually began to shift from the old near-west side campus to the new lakeshore campus. The move marked the end of one era and the beginning of another. The sandy brushland, formerly known as Hayes Point and used for family picnics by early residents of Rogers Park, would slowly become known as Loyola's lakeshore campus; the term *Hayes Point* would pass out of the collective memory of Rogers Park residents. Even the nearby train station would change its name from Hayes to Loyola by 1921. Still, for a brief bit of time, when Loyola was the "new kid on the block" and before building after building was planned and constructed, the center of Loyola University sat among lush greenery and open space. (Courtesy of Loyola University Chicago Archives.)

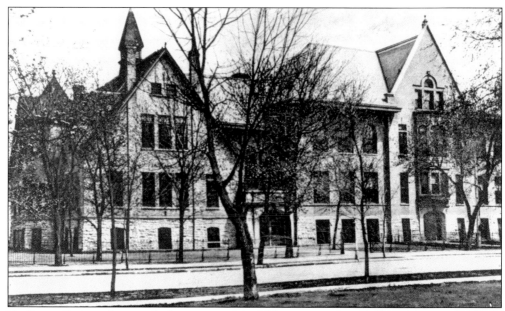

For Rogers Park residents at the beginning of the 20th century, education was a top priority. Both the West Side Schoolhouse, constructed in 1872 near the present-day site of Rogers and Damen Avenues, and the East Side School House, built in 1878 at present-day Greenleaf and Ashland Avenues, had earned reputations of excellence. The influx of new residents after annexation necessitated a larger facility, and the East Side School was slated for expansion. In 1899, with renovations complete, the East Side School was renamed Eugene Field School after the renowned children's poet and the author of "Wynken, Blynken, and Nod." The West Side School closed its doors, although the building was used as a residence for a time before it was demolished. Below, Rogers Park students pose for their class photograph in 1894. (Courtesy of RP/WR HS.)

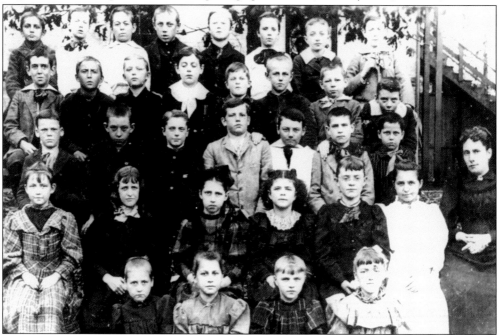

The period between 1901 and 1910 is often called the "Beautiful Age," as there was a definite leaning toward classical aesthetics, and for privileged little girls, fashionable clothes were definitely in. Pale cream, white, ivory, and softer, daintier, lighter fabrics replaced the heavy plush and thick materials popular in the previous decade. Lace-up boots with small heels were also part of the look. (Courtesy of RP/WR HS.)

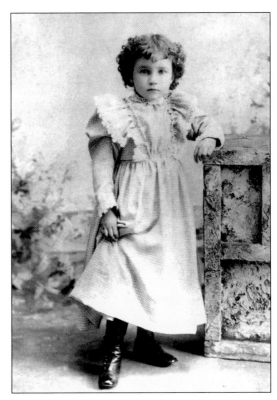

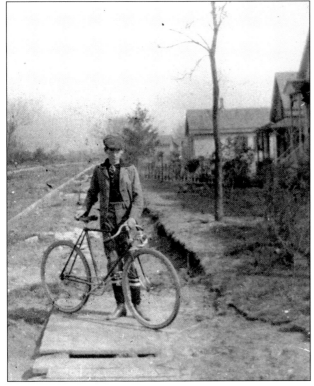

By the 1890s, bicycles had evolved from the dangerous "high wheel" design to the pneumatic-tired safety model shown here, and improvements in manufacturing techniques meant they were no longer just for the wealthy. In some areas, the bicycle craze preceded paved roads and sidewalks. This young man, perched on the east side of Ridge Boulevard around 1900, receives an early taste of all-terrain cycling. (Courtesy of RP/WR HS.)

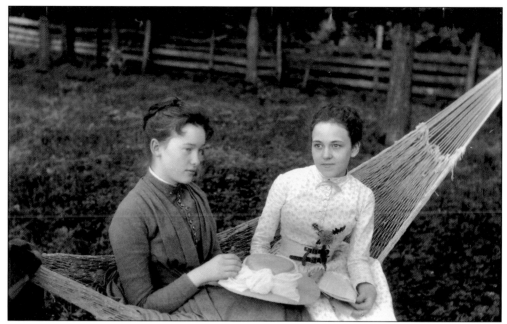

The Wilkins family moved to the 1100 block of West Lunt Avenue in 1899 to become part of the neighborhood's cultured class. The Wilkins women were cultivated and sophisticated, interested in the arts and travel. Pictured here are Mary (left) and Gertrude. Josephine Wilkins (not pictured) lived in the Wilkins house on Lunt Avenue throughout her lifetime and is remembered as an adventuresome, fiercely independent woman, who drove an automobile even after the age of 90. (Courtesy of RP/WR HS.)

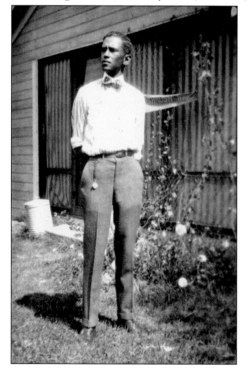

Luther Pollard stands lean and handsome in this 1917 photograph. A multifaceted man, he tried his hand at many professions, including athletics and filmmaking—some Rogers Parkers recall, as children, running across a Luther Pollard film production on occasion. Luther's nephew, Olympian Frederick Douglass "Fritz" Pollard Jr. recalled, "Luther was the oldest boy and they all halfway looked up to him. . . . Luther did some strange things. I mean, Luther was the only black that had an office downtown. Right down on Michigan [Avenue]. He was a real enterpriser," as told to John M. Carroll in *Fritz Pollard*. Luther went on to bear the distinction of the person who had lived the most years in Rogers Park. (Courtesy of RP/WR HS, Pollard family collection.)

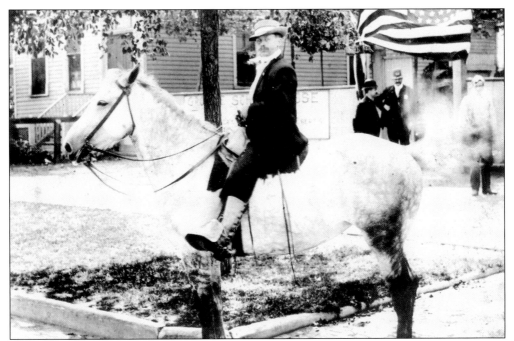

No community is without its characters. Perry Darbenfeld, the unofficial mayor of Rogers Park, sits regally upon his horse during an Independence Day celebration in 1905. No longer its own village, Rogers Park could not technically have a mayor, but in the true spirit of things, Darbenfeld led this parade and many others. (Courtesy of RP/WR HS.)

The trial of Dr. Haldane Cleminson for the murder of his wife Nora Jane has passed from modern memory, but in 1909, it was front-page news. Death by chloroform, an alleged burglary—police quickly arrested and charged the good doctor. Cleminson attended the funeral, under police guard, at their home at 6823 North Wayne Avenue in Rogers Park. "Every eye in the room was on him," reported the *Decatur Daily News*. (Courtesy of Chicago History Museum, DN-0054562.)

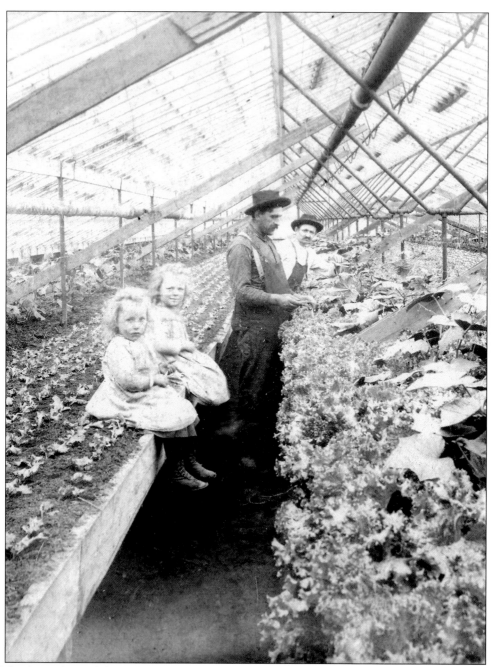

Like the Irish, English, and Germans, Luxembourgers were among the first wave of immigrants into the Rogers Park area. By the late 1800s, the Nepper family established a substantial urban greenhouse, growing lettuce and celery. Truck farming, producing fruit and vegetables for the Chicago market, was a prevailing occupation for Luxembourgers in Rogers Park and West Ridge. Here Peter Nepper (center) works with a hired hand, as Catherine and Louise Nepper keep him company. The more boys in a greenhouse family, the more hands to tend the produce. "My grandfather envied any greenhouse man with boys," said Nepper's grandson Leo Kinsch. (Courtesy of Kinsch family.)

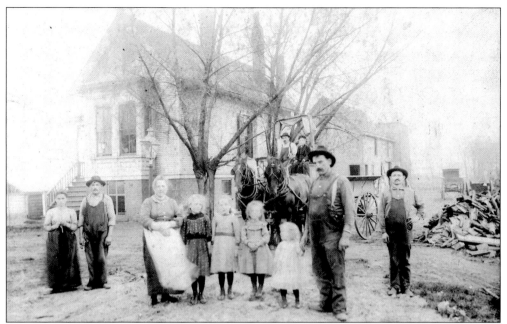

Above, mother Anna, daughters Mary, Margaret, Catherine, and Louise, and father Peter Nepper stand surrounded by farmhands on either side. The eldest son, Frank, sits on the wagon. The house, south of Birchwood Avenue on Hilldale Avenue (now Wolcott Avenue), was a target for dust thrown by traffic. "They had to wash those windows every day," said Kinsch. The greenhouses stretched two to three city blocks. By 1905 (below), the family's circumstances changed considerably, including a move to a much bigger house and a new family member, youngest son Peter Jr., who would die before reaching age 10. The introduction of refrigeration meant less and less demand for urban greenhouse farming, and the greenhouse growers made the transition from vegetables to flowers. This house stands today on the southwest corner of Wolcott and Birchwood Avenues. (Courtesy of Kinsch family.)

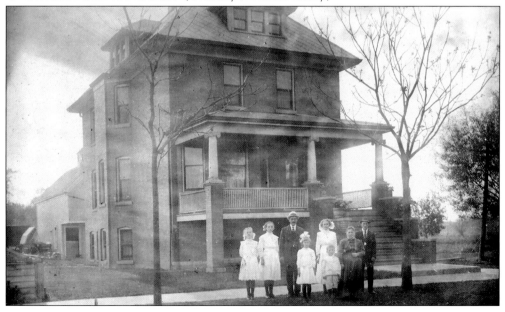

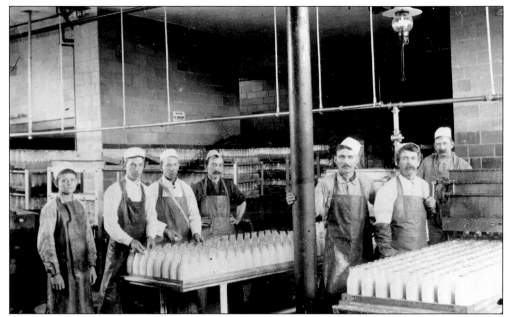

Workers prepare milk for the milkman in one of Rogers Park's dairies. As evidenced by the vast number of bottles in the background, this urban dairy supplied a substantial number of people. In 1908, Chicago mandated the pasteurization of milk, the first city in the nation to do so. Even into the 1940s, it wasn't uncommon to see a milkman tooling around Rogers Park in a horse-drawn wagon. (Courtesy of RP/WR HS.)

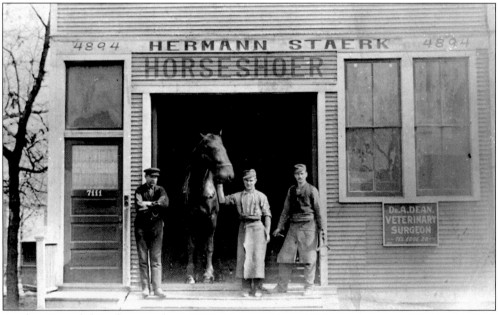

At the time of this photograph in 1919, Hermann Staerk's Horseshoer at 7111 North Clark Street still features the numbers 4894, its address prior to the 1908 reformation of Chicago's street numbering system. Some Rogers Park business owners, like Staerk, kept the old numbers up, perhaps as an homage to the old days and maybe so old friends could still find the place. (Courtesy of RP/WR HS.)

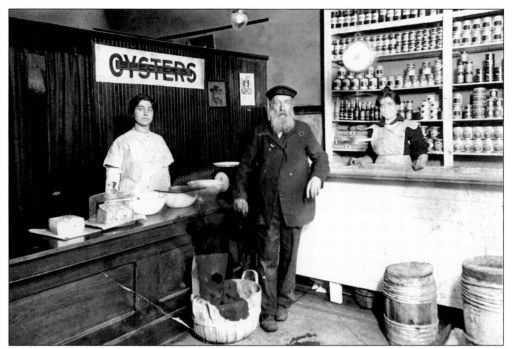

During the 1890s (the "Gay Nineties"), luxury items were becoming available at local stores. Oysters, in particular, became very popular. In fact, between 1890 and 1910, it is estimated that close to half a billion oysters were harvested each year along the east coast and shipped into New York City, London, Liverpool, San Francisco, Chicago, and St. Louis. (Courtesy of RP/WR HS.)

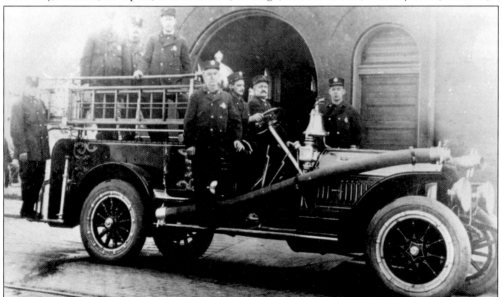

In 1912, Rogers Park became one of the first neighborhoods to say goodbye to the fire department's horse-drawn wagons, when a 650-gallon-per-minute rotary pumper was assigned to Engine 102's quarters. "It was located here, out in the boon docks, so if and when it broke down, no one would notice," wrote historians Ken Little and John McNalis. Within about 10 years, all Chicago fire stations had switched to rotary pumpers. (Courtesy of RP/WR HS.)

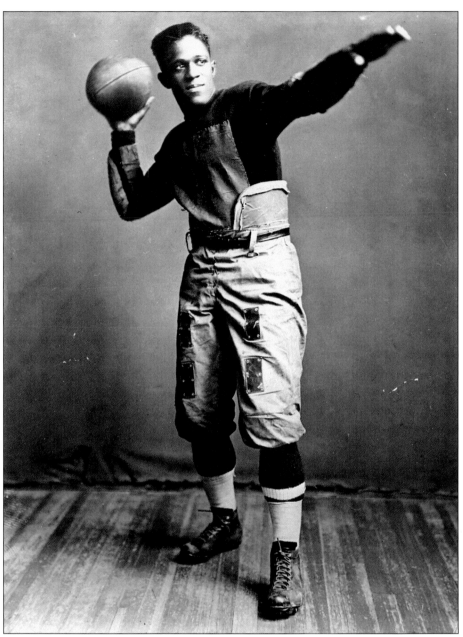

Rogers Park's early star athlete, Frederick Douglass "Fritz" Pollard Sr., became the first African American NFL coach a full quarter century before Jackie Robinson broke baseball's color barrier. Born January 27, 1894, the seventh of eight children to Rogers Park barber John William Pollard and Amanda Hughes Pollard, young Fred earned his moniker of fame, Fritz, from his Luxembourger and German boyhood friends. Pollard attended Albert Grannis Lane Technical High School (Lane Tech), and in 1915, won a Rockefeller Scholarship to Brown University. He led Brown to the 1916 Rose Bowl, the first African American to play at the event. In 1922, he became the first black NFL coach, a position that would not be held by another African American until 1989. Pollard, who died in 1986, would not live to see his 2005 induction into the Pro Football Hall of Fame. His boyhood home stands today in Rogers Park. (Courtesy of Brown University Archives.)

Four

THE NORTH SHORE OF DAYS PAST

I'd like to live as a poor man with lots of money.

—Pablo Picasso

With its lake access, unsurpassed beauty, and distinctive charm, Rogers Park became popular with the affluent who wanted to escape the grit of urban life by moving far north of the pungent odors that pervaded the downtown area. The result was a lakeshore community of fine homes and landscaped grounds. Where parks and jammed apartment complexes now exist, yesterday's lakefront was lined with huge, lavish houses and lush lawns. For a short time, before further development, Rogers Park's lakefront was part of the famous North Shore.

The opening of the Howard Station in 1908 made it possible for more and more of the white-collar class to commute to downtown while living among their peers in Rogers Park. The industrial age and accompanying economic growth transformed the eastern section of Rogers Park into a corridor of prosperity. The newly affluent class displayed their prosperity by hiring domestic servants, dressing fashionably, and joining in leisure activities.

Development took off and the area began to flourish, as people with money wanted to spend it. Shopkeepers kept shelves well stocked, and as demand for services rose, new stores went in. Circulation of wealth raised the economic status of Rogers Park, transforming it into one of Chicago's posh neighborhoods.

It was also a time of undulating unrest, however, and significant shifts in ways of life lay on the horizon. Across the nation, women marched for the right to vote, Margaret Sanger opened a family planning and birth control clinic, and important legislation concerning child labor was passed. On the south side of Chicago, thousands of African Americans who traveled north as part of the Great Migration were already being ghettoized by invisible boundaries. To top it off, World War I was raging in Europe.

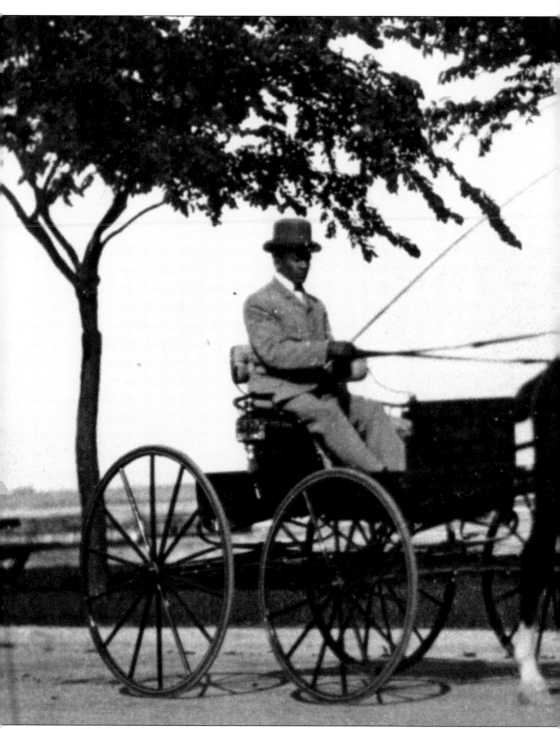

For 19th-century Chicagoans, carriages not only provided transportation, they also served as very public symbols of one's status. One glance at the design of the carriage, the breed of the horse, and the number and race of the coachmen, revealed the status of the family. The burgeoning middle class also displayed prosperity by hiring domestic servants who would cook,

clean, and watch the children. These domestic servants, carriage drivers included, usually lived with their employers. For coachmen, that generally meant a small room above the stable in the coach house. Between outings, these men kept busy by tending the horses and caring for the equipment. (Courtesy of RP/WR HS.)

Albert Wheeler, the chief engineer of the Chicago Tunnel System, was one of the wealthy new homeowners in the area. His wife, Cassie, an amateur artist and architect, had been collecting design ideas for over 40 years and painstakingly designed their 1909 mansion on Sheridan Road. Called a masterpiece by Daniel Burnham, today it is Loyola University's Piper Hall. (Courtesy of Mundelein College Records, Women and Leadership Archives, Loyola University Chicago.)

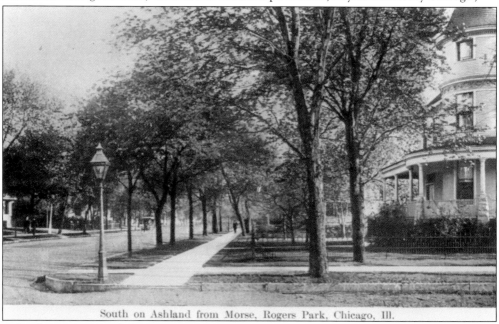

South on Ashland from Morse, Rogers Park, Chicago, Ill.

Other homeowners, while not as wealthy as the Wheelers, still enjoyed the luxuries of wide, lighted streets, manicured lawns, abundant trees, and a pastoral setting, as depicted here looking south on Ashland Avenue from Morse Avenue. Telephones, vacuum cleaners, and electric irons were also becoming commonplace, and outdoor sports like badminton and croquet were the rage. (Courtesy of RP/WR HS.)

Life became decidedly more urban in Rogers Park, and women enjoyed a more comfortable lifestyle. Domestic servants assisted with their household chores enabling more access to new entertainment, literature, art, and a variety of genteel pursuits. These were the days of the suffragettes, and 10 miles to the south of Rogers Park, Jane Addams was writing the essay "Why Women Should Vote." (Courtesy of RP/WR HS.)

The Rogers Park Woman's Club established a library and reading room that would later become part of the Chicago Public Library System and championed other civic causes, many related to child welfare. The Woman's Club members included the wives of prominent businessmen as well as working professionals such as physician Dr. Bertha Bush, who ran her practice as early as 1901 on Clark Street. Her sister, Laura Bush, was an area pharmacist. (Courtesy of RP/WR HS.)

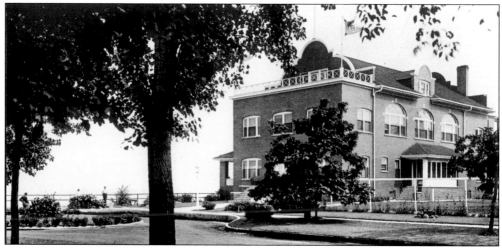

Catering to the newly affluent, developers created a first-class subdivision from Touhy Avenue to Birchwood Avenue and from Chicago Avenue (now Clark Street) to the lake. Called Birchwood Beach, it featured wide streets, sandstone walks, and private homes—no apartment buildings or flats were permitted. The developers set aside some land along Lake Michigan for neighborhood recreation, and a group of residents opened the Birchwood Country Club there in 1906. (Courtesy of RP/WR HS.)

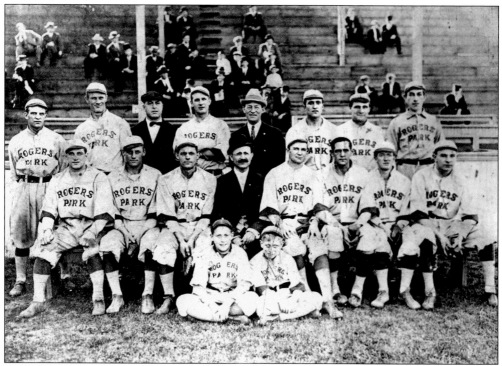

Chicago made baseball history in 1906 as the first city to send two teams to the World Series—the south side White Sox and then-west side Cubs. The Sox took the series, beating the Cubs four out of six games. The Rogers Park Baseball Club played its first games in 1906, and entertained fans at the Rogers Park Baseball Grounds near the corner of Devon Avenue and Clark Street until 1916, when the ballpark closed. (Courtesy of RP/WR HS.)

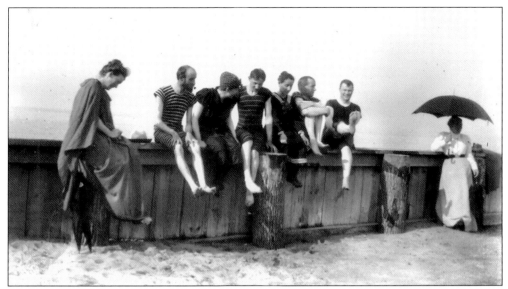

In 1915, a *Chicago Tribune* headline declared, "The People of Chicago Discover Lake Michigan." Beaches were extremely popular at this time and a convenient place for boys and girls to meet. Suitable bathing clothes were required, however. Women's suits needed to have quarter-length sleeves and trunks "not shorter than four inches above the knee." Anyone failing to meet these requirements could be fined "not less than five dollars nor more than twenty dollars." (Courtesy of RP/WR HS.)

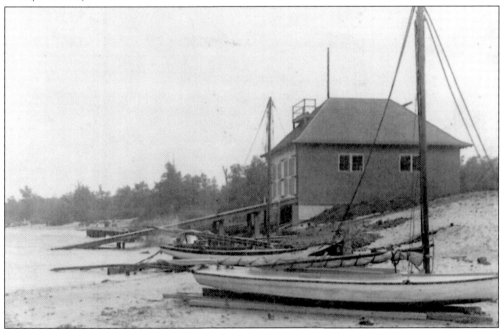

The Rogers Park Life Saving Station was built in 1906 and manned by a volunteer crew. Over the years, the crew attempted many rescue missions. In 1909, they pulled two fishermen from danger and saved four boys and a dog from high waves in 1913. In the winter of 1915, lifesaver John Kerns dove into the icy water to recover the body of an 84-year-old female suicide victim. (Courtesy of RP/WR HS; photograph by C. R. Childs.)

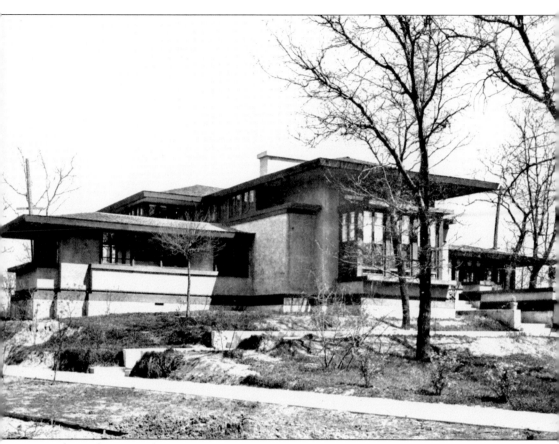

When Chicago architectural mogul Louis Sullivan learned that his employee Frank Lloyd Wright was designing houses to earn extra cash, he promptly fired the young architect. Sullivan, who later lost the bid for the 1893 Columbian Exposition to Daniel Burnham, could not have done the world, and Rogers Park, a bigger favor. Sheridan Road has been graced by not one, but two houses designed by the bard of the prairie-style edifice. The most widely known is the 1915 Emil Bach House, but the neighborhood's first Wright home stood a few blocks north, on the southeast corner of Rogers Avenue and Sheridan Road. Completed in 1909, the house was subsequently sold to Otto Bach in 1912, one of several brothers who ran the Bach Brick Company. The house became the King's Arms restaurant in the 1930s and fell to the wrecking ball in 1963. (Courtesy of Library of Congress, HABS ILL,16-CHIG,64-1.)

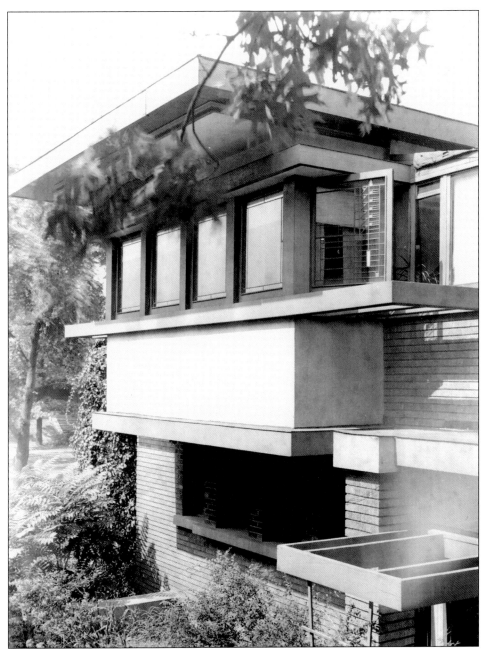

Otto's brother Emil commissioned the single-family home that was to age as gracefully as fine wine in the midst of the dwarfing rise of urban geography. Completed in 1915, the smart, compact prairie-style structure of Emil Bach's house adapted spatially to its street front location (7415 North Sheridan Road), rooting comfortably as the neighborhood grew around it. Years later, Emil Bach's widow, Anna M. Bach, wrote to the new owner, "The Bach home, as you called it, was never built for a summer home. . . . It was planned and built for a permanent home and a thing of beauty." Anna also debunks theories of its high cost: "It never cost anywhere near $100,000 or we would never have owned it." The value of this official Chicago landmark is considerably higher today. (Courtesy of Oak Park Public Library.)

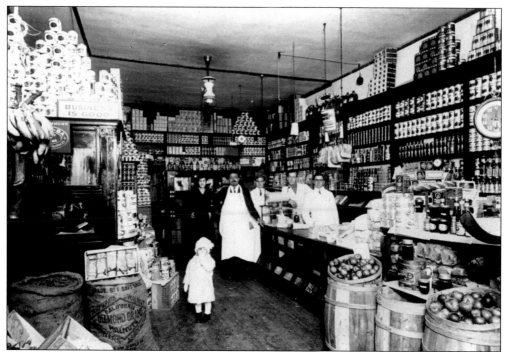

Shoppers could find just about anything they wanted in the neighborhood's well stocked grocery stores, including three Chicago-based favorites: Wrigley's chewing gum (introduced 1892), Cracker Jack (popularized at the 1893 World's Columbian Exposition), and Brach's candy (established 1904). Canned goods were also becoming more commonplace. (Courtesy of RP/WR HS.)

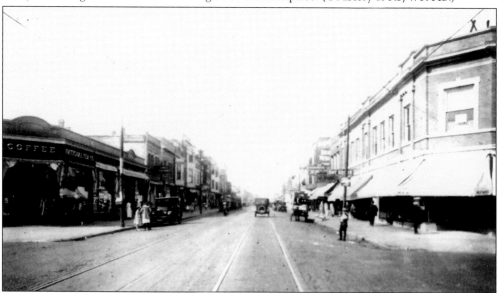

In 1913, a development project brought as many as 70 multifamily apartment buildings to the area north of Devon Avenue near Clark Street. By 1915, the date of this photograph, the rapidly growing population of Rogers Park's southern, inland area enjoyed Clark Street's offerings of cafés, banks, clothing stores, and restaurants. This was merely a hint of the massive development boom to come to Rogers Park in the coming decade. (Courtesy of RP/WR HS.)

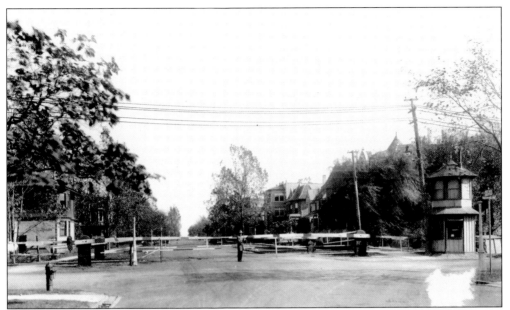

Elevated trains, or L service, were closer to becoming a reality in Rogers Park in 1907, when the Chicago City Council authorized the electrification of the tracks of the Chicago, Milwaukee and St. Paul Railway from Graceland Avenue to Howard Street. The Northwestern Elevated Railroad took over operation of the line and opened the Howard Station in 1908. The electric L replaced the steam service that the St. Paul had previously provided. (Courtesy of Chicago Transit Authority.)

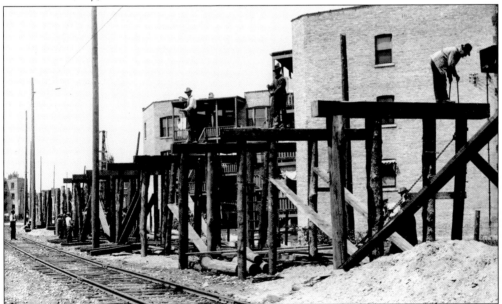

Initially the tracks were grade-level and electrified by overhead trolley wires, but in the middle of the second decade of the 20th century, the Northwestern began to elevate the tracks north of Wilson Avenue. In early 1916, trains were moved onto a temporary trestle, but construction of a permanent embankment had to wait until the end of World War I, due to a materials shortage. (Courtesy of Chicago Transit Authority.)

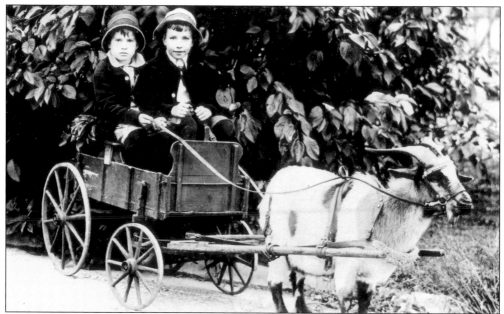

Norm Coughlin, one of the boys in this goat-drawn buggy around 1914, would later grace local publications with wistful prose as he recalled his childhood, "The alleys in the teens and twenties were quite different than they are today," wrote Coughlin. "In the main, they were muddy and uneven, but then, so were many streets. After a rain of any consequence, in some areas there was a jumble of large puddles that became quagmires." (Courtesy of RP/WR HS.)

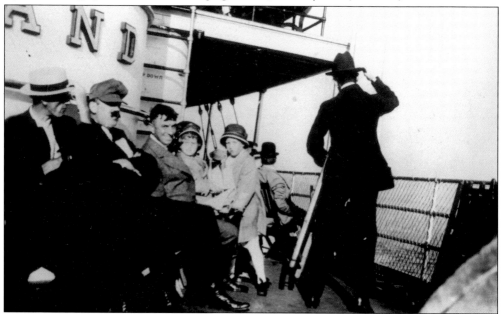

This photograph, dated around 1915, shows a young Coughlin on the lap of a man who is likely his father, out for a trip on the *Eastland*, a popular passenger tour ship. Judging from the way they are dressed in the photograph, it is likely springtime, still cool enough for jackets. Later that summer, 845 people died when the unstable, top-heavy vessel tipped over on the Chicago River. (Courtesy of RP/WR HS.)

Here young John "Jack" Zender, a direct descendent of the area's first saloon owner, John Zender, drapes an arm over the shoulder of his younger sister Catherine, around 1913. The Zender children grew up in and around Rogers Park, the family having gone from the business of liquor to flowers. Jack became a regular fixture on Howard Street, as co-owner of Zender's Florist with his father, Jacob. (Courtesy of John J. Zender Jr. collection.)

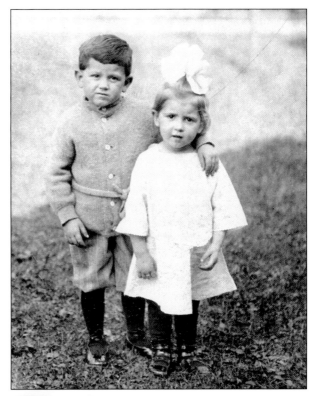

In the years leading to the war, Rogers Park sported some of the city's most affluent lakefront properties, saw the rise of a university, and was about to undertake a building boom that would catapult it into an era of grandeur. As war raged in Europe, Rogers Park residents increasingly turned their attention east, across the ocean to Germany, a place not more than a generation or two removed from many of them. (Courtesy of RP/WR HS.)

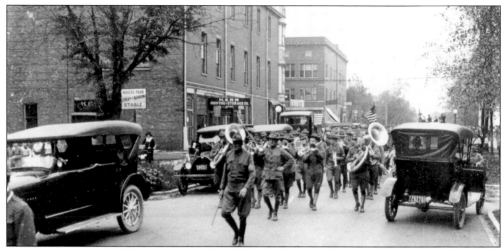

New recruits, above, parade down Lunt Avenue in 1917, off to fight the war in Europe. Although World War I began in 1914, the United States remained neutral and waited until 1917 to enter on the side of the Allies. In Chicago, there was not a massive galvanization for this war, especially compared to the patriotic fervor of World War II, partially due to Chicago mayor Bill Thompson's assertion that any alliance with Britain would be "traitorous." There was also a large German contingent in Chicago, many who supported the other side. Regardless, many did join up, and the total enlistments in Illinois numbered 351,153. To the left, Norm Coughlin salutes with his friends in front of his house on Bosworth Avenue. (Courtesy of RP/WR HS.)

Five

THE JAZZ AGE

When I sell liquor, it's called bootlegging;
when my patrons serve it on Lake Shore Drive, it's called hospitality.

—Alphonse Gabriel Capone

With World War I at an end, Americans were in the mood to celebrate, and the Roaring Twenties brought a pop culture explosion into the Rogers Park scene in a way unparalleled before or since. People of the North Shore, under the grip of temperance, escaped to Howard Street's hot nightclubs and the grand theaters that presided over Rogers Park's border streets—the Howard Theater, the Norshore Theatre, the Adelphi Theater, and the unequaled Granada Theater. The passage of the 18th Amendment, declaring the making and distribution of distilled spirits illegal in the United States, did little to stop the flow of liquor in Rogers Park's night scene. Some say there was more drinking during Prohibition than in any other time. Women, emboldened by the vote, strode audaciously into the 1920s by cutting their hair, raising their hemlines, and appearing with men in places considered unsuitable for ladies.

Money flowed like honey during this time. Rogers Park grew to an astonishing 57,000 residents in 1930 as a construction boom, unparalleled even today, saw multifamily apartment complexes sprout like Jack's bean stalk across the boulevards and streets, defining the urban geography of the neighborhood. Businesses, places of worship, and hotels quickly rose to keep pace with the demands of a growing population. It was a time when working stiffs could afford to dress up for an afternoon at the picture show.

It also was a time when Chicago's African American community—and African Americans across the nation—lived a life of enforced segregation. During the 1920s, few African Americans lived in the neighborhood, and those that did moved in a realm invisible to whites, often occupying roles of servitude. Despite nationwide oppression, African American arts and culture flourished in the 1920s—the Harlem Renaissance, the Cotton Club, and Louis Armstrong's jazz culture on Chicago's South Side rendered Howard Street pale in comparison. But in its own right, Howard Street was a hip place to be in the 1920s.

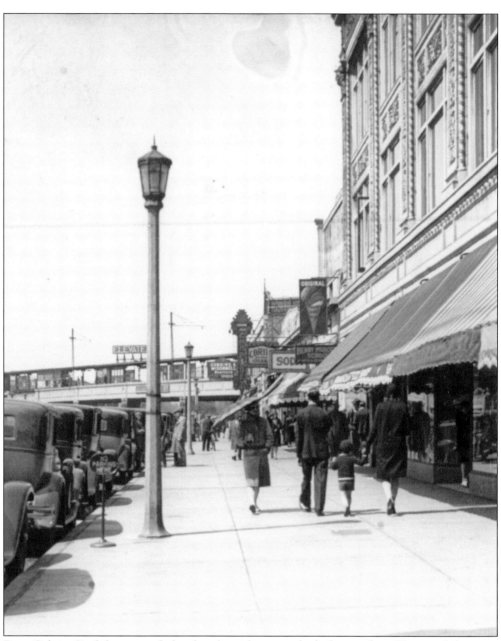

Pres. Calvin Coolidge opened the decade with a speech declaring that, "America's business is business," and Rogers Parkers took up the call. Businesses sprang up throughout the neighborhood, and the area rapidly grew more urban and increasingly commercial. Jewelry, fine clothes, and the latest modern conveniences were available at the major shopping areas on Clark and Howard Streets, Devon Avenue, and seen here on Sheridan Road. Rogers Park embraced this new era of consumerism and here, as across America, women became the primary buyers and the main target of marketers. Newspapers and magazines touted the various goods and services now available, and motorcars, more affordable and in the commercial fray, began to dominate the streets. (Courtesy of Chicago History Museum, DN-0088482; photograph by Chicago Daily News.)

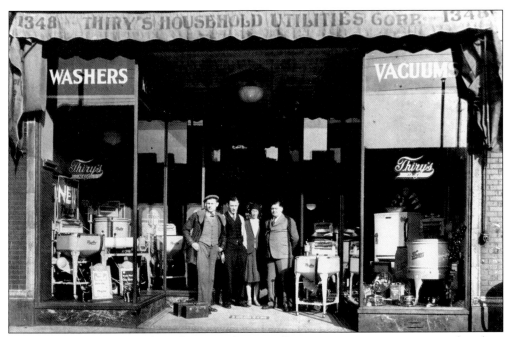

Toasters, dishwashers, and washing machines—all recent inventions—were marketed as "electric servants" that would make housework less strenuous and less time-consuming, freeing the modern woman to enjoy the day's leisure activities. These items, along with other electric appliances, were available at Thiry's Household Utilities (1348 West Devon Avenue), which operated from 1920 until the early 1930s. (Courtesy of RP/WR HS.)

Rogers Park's Dorothy Grant (left), a queen of Chicago's second Pageant of Progress, relaxes at Municipal Pier (Navy Pier). The 1922 event featured exciting exhibits, performances, and air and water shows. This pageant, along with the first in 1921, made such a hit that Chicago officials decided to host another world's fair. The 1933 "Century of Progress" celebrated the centennial of Chicago's incorporation as a village. (Courtesy of Chicago History Museum, DN-0074526; photograph by Chicago Daily News.)

At the dawn of the Roaring Twenties, jobs were plentiful and people of all classes enjoyed more comfortable lives. Fashionable clothes, even for children, were a common indulgence. These 1920s Rogers Park kids sport the gamut of the day's fashions, including jewelry, knickers, and smart button-down jackets. Hats were the thing in the 1920s, from the safari-style donned by James Sampson (second from left) to the ever-popular "Gatsby" cap worn by the boy on the right. James, or "Jay" as he was called by those close to him, is flanked by his sister Genevieve and younger brother Robert. (Courtesy of RP/WR HS.)

The development boom of the 1920s laid ink to the signature look of Rogers Park's urban geography. Multifamily dwellings went up all over the neighborhood, as families made Rogers Park their home. Here a family stands in front of a 19th-century Victorian farmhouse, while telephone poles and brick apartment buildings loom in the background. Renters quickly became far more numerous than homeowners. (Courtesy of RP/WR HS.)

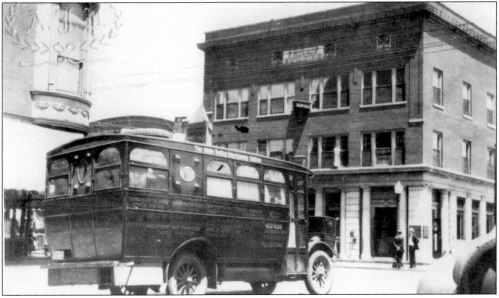

During this time, development took off in the business districts, and apartment complexes sprung up by the scores to accommodate Rogers Park's rapidly growing population. The 1920s marked the most prolific growth in the neighborhood's history, unmatched by any other period of the century. This era also saw the rise of combined commercial and storefront buildings with residential apartments in the upper floors on main thoroughfares like Morse Avenue and Pratt Boulevard. (Courtesy of RP/WR HS.)

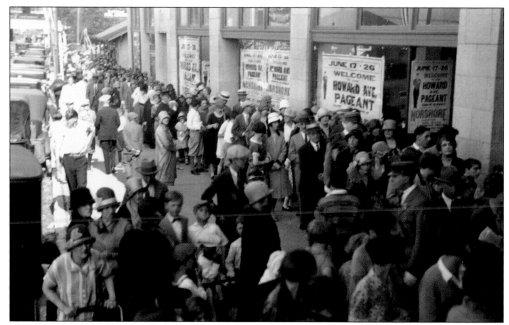

Throngs of people form a line that stretches back to the Howard Street L, dressed up and barely a head without a hat, in anticipation of the Howard Street Pageant at the brand-new Norshore Theatre. Howard Street was a popular place in the 1920s, drawing crowds by the thousands from the quiet and very dry North Shore to the luminous excitement of Chicago's top border street. (Courtesy of RP/WR HS.)

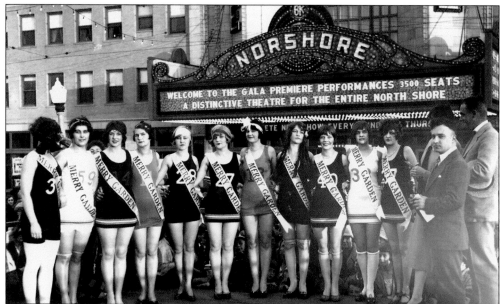

"I could look at a woman's legs for hours," Charles Bukowski once wrote. With the advent of the Miss America Pageant in 1921, beauty contests became a national sensation, drawing crowds by the thousands. In Rogers Park, like everywhere else, people were more than willing to separate themselves from hard-earned coin for a glimpse of the glitz and glamour of the age, especially if the glimpse involved the biggest seller of all time—sex. (Courtesy of RP/WR HS.)

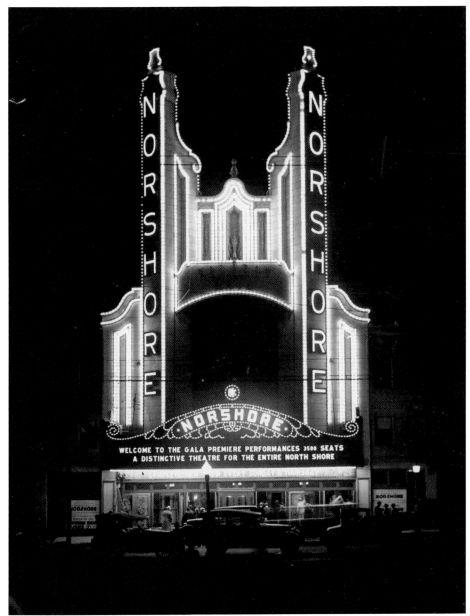

The Norshore's marquee hangs over Howard Street at night, glowing with all the promise of the Jazz Age—gala premiere, distinctive theater, and 3,500 seats. Built in 1926, the grand house's managers, Balaban and Katz, knew how to put it on. This was no clip joint, and it wasn't vaudeville. The Norshore Theatre exuded class. Huge crystal chandeliers and Pompeian motifs lined the ceiling, and very fine French antiques decorated the upper lobby. It was a real cut above most theaters, a sister to the Granada Theater also in the Balaban and Katz style. The stage hopped with performances in the very popular Paul Ash–jazz style of the day. One 1928 summer advertisement in the *Chicago Daily Tribune* featured a headline show by Frankie Masters, at the time a regular in the clubs around the North Side. The style here was "movie theater" jazz. On the south side, where Louis Armstrong reigned, it was a whole different kind of sound. (Courtesy of RP/WR HS.)

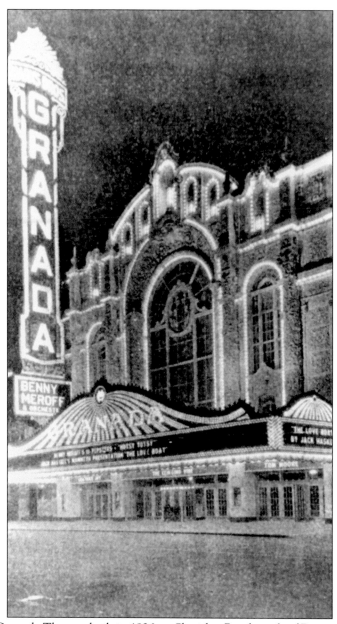

The gorgeous Granada Theater, built in 1926 on Sheridan Road north of Devon Avenue, played host to the "Shimmy-She Wabble-Girl" Bee Palmer. Palmer popularized the shimmy-shake dance, described as "a sinuous and suggestive undulation of hips and shoulders," and claimed the title "Shimmy Queen" in 1918. In an interview with the *New York Telegram* she is quoted as saying, "It is true my shoulders are responsible for my success. I dance with them." Gilda Gray and Mae West also claimed to be the true inventors of the shimmy, although it most likely had African origins. The shimmy was just one of the dances to gain popularity during the 1920s. Other dances included the breakaway, the Charleston, and the black bottom. Crowds flocked to the Granada Theater to catch a glimpse of star-powered live entertainment and, when live shows were not offered, to catch the latest movie. (Courtesy of Library of Congress, HABS ILL,16-CHIG,109-30.)

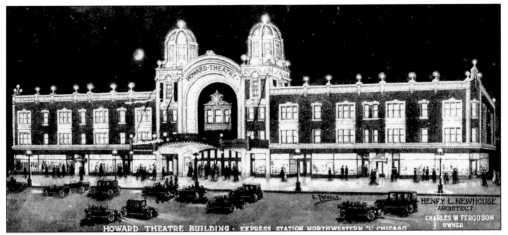

During the 1920s, Howard Street was one of the busiest entertainment spots on Chicago's North Side. The Howard Theater had gone up in 1918, and was quickly followed by subsequent apartment, retail, and café construction. By the 1920s, Howard Street was hailed as the "Street of Fortune," and the area surrounding the theater was known as the "Wonder District." (Courtesy of RP/WR HS.)

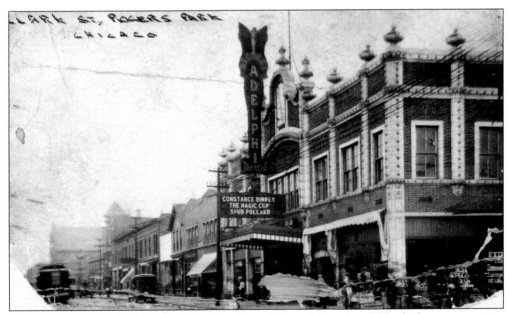

"Don't do it! Don't do it!" yelled Leo Kinsch, at Ollie, of Laurel and Hardy fame, attempting to steal something on the silver screen. Ollie didn't listen, and afraid of what would happen, Kinsch, the grandson of greenhouse farmer Peter Nepper, left the theater and ran home. It was his first talkie and his first visit to the enchanting Adelphi Theater (7074 North Clark Street). The theater, built in 1917, was razed in 2006. (Courtesy of RP/WR HS.)

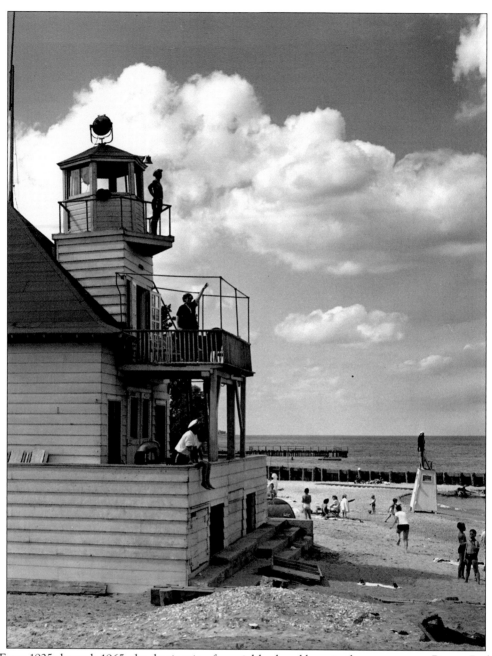

From 1925 through 1965, the destination for neighborhood boys in the summer was Rogers Park and Beach (now Leone Park and Beach). It was not just the sun and sand that drew them there, they came because of Sam Leone. Leone (on the lower porch, looking over the beach), who had served in the U.S. Navy during World War I, coordinated the lifeguard programs at the beach and taught the boys in the neighborhood to handle themselves in the not-so-kind waters of Lake Michigan. Neighbors recognized his ability to inspire young people in his care. Each day was an endurance test for Leone's junior guards, or "Sam's Boys." On special occasions, as a reward for their hard work, Leone would pull 12 or more water-skiers behind his boat, *The Alert*, from Rogers Park to the Loop and back. (Courtesy of RP/WR HS.)

Although Sam Leone was not the founder of the junior guard program, he certainly popularized it. Unlike his predecessor Tom Daly, Leone realized that most young boys would not want to spend hot summer days guarding a stretch of beach when all of their friends were playing in the water—unless, of course, they were rewarded with other fun activities. So he kept the patrol assignments short and set up football games, picnics, and canoe races to fill the space between. He even took his junior guards on fall camping trips as depicted in this 1933 photograph. (Courtesy of Leone Beach Archives.)

During the 1920s and 1930s, the spatial structure of the city of Chicago was quite different than today. The only truly wealthy close-to-downtown neighborhood was a tiny sliver of the Gold Coast. Virtually all the other neighborhoods around the downtown area—even Lincoln Park—were among the poorest communities in the city. Conversely, outer-city neighborhoods like Rogers Park were among the wealthiest. According to research by the first urban studies scholars at the University of Chicago, Rogers Parkers were members of the city's highest economic class (based on the range of median rentals in dollars) and had achieved the city's highest educational status (over 60 percent of the neighborhood's adult population had completed high school or attended college). For Elsie Traut (seated) and onlooker Greg Sampson (second from right) Rogers Park was the place to be. (Courtesy of RP/WR HS.)

Baby Valerie and big sister Charna Kohn are seen here on the corner of Lunt and Greenleaf Avenues during the winter of 1927. The photograph was snapped at the height of the neighborhood's population explosion. With less than 10,000 residents in 1915, the community had catapulted to more than 57,000 by 1930. The growth was made possible by the 1915 annexation of Germania (the land north of Howard Street and south of Calvary Cemetery) and the rapid construction of multi-unit apartment buildings throughout the decade. To serve the growing number of children in the area, two new schools were established. The Stephen Francis Gale Elementary School (1631 West Jonquil Terrace) opened its doors in 1922, and the Joyce Kilmer Elementary School (6700 North Greenview Avenue) welcomed its first class in 1931. (Courtesy of RP/WR HS.)

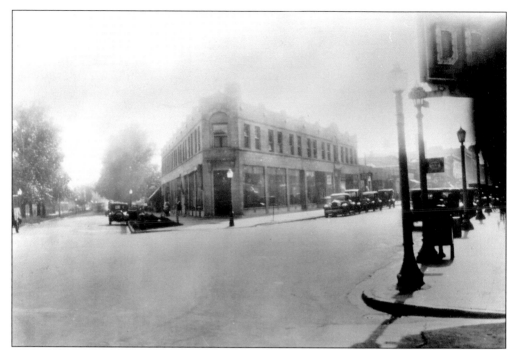

One of the most revolutionary changes in the 1920s was the arrival of the automobile. At first expensive toys for the rich, they became affordable enough for average people to own as low-interest credit became commonplace. Here is the car-lined corner of Rogers Avenue and Howard Street of the day. The flatiron-shaped Bishop Building is named for the man who built it, Harry Bishop, whose ghost apparently haunts it to this day. (Courtesy of RP/WR HS.)

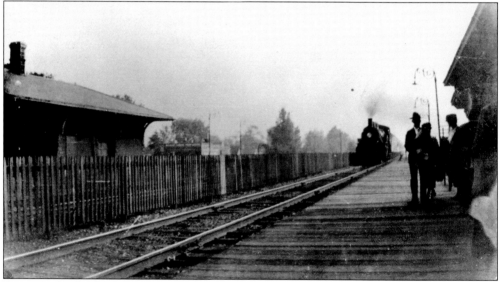

Rogers Park's development, like many other areas of Chicago, was due in large part to the transit lines. Wherever the trains went, apartment building, subdivision, and bungalow construction followed. The majority of people moving out to these new homes relied on mass transit to bring them back downtown to work and shop. Chicago's Union Station was built in 1924. Mass transit ridership reached an all-time high in the city in 1926. (Courtesy of RP/WR HS.)

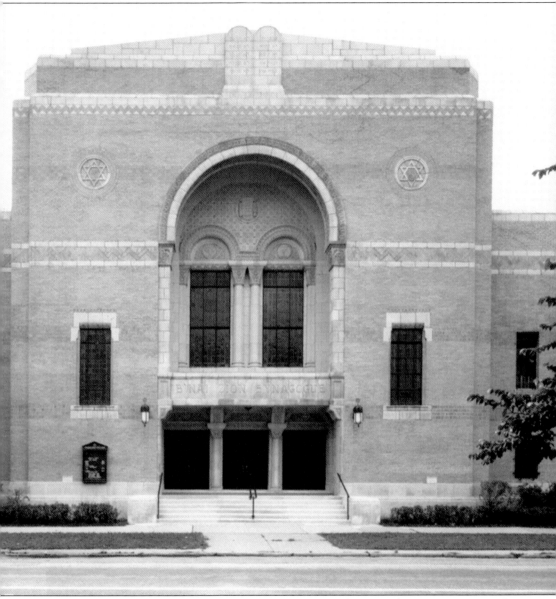

For many west side Jews, Rogers Park, with its tree-lined streets and spacious homes, was a targeted destination. Recognizing this, Herman Spivak, Joseph Friedman, and Edward Steif met in 1918 to form a new synagogue named Congregation B'nai Zion. The first meetings were in members' homes, then in temporary quarters near the corner of Clark Street and Lunt Avenue, but by the mid-1920s, the community was financially strong enough to purchase land and build a permanent home. The grandiose, modern Romanesque-style synagogue at 1447 West Pratt Boulevard, with its ballroom-sized sanctuary and towering stained-glass windows, was built in 1926 and officially dedicated in 1928. Led by Rabbi Abraham Lassen, it was the first conservative synagogue in Chicago and at its opening, had a congregation of 350 families. "Congregation B'nai Zion was our second home," remembers Beverly Tatz who joined in 1945. "We went there practically every day and even celebrated birthdays there." (Courtesy of RP/WR HS.)

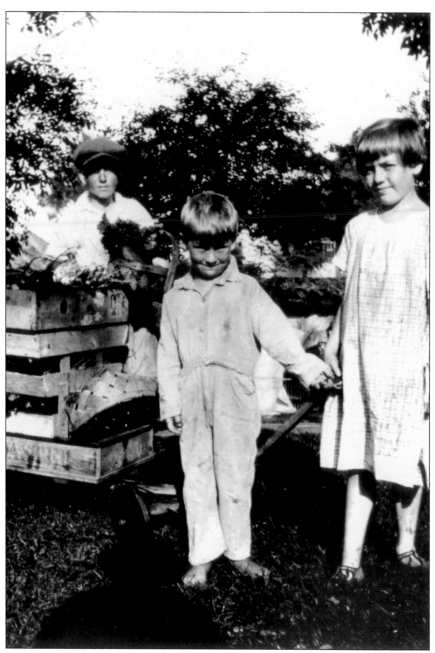

The Roaring Twenties have earned a special place in history as a time of great jazz, F. Scott Fitzgerald, William Randolph Hearst, and Al Capone. Everything seemed magnificent—big business, big headlines, big names, and big spenders. But beyond the flashbulbs, newspaper headlines, and ticker tape, it was also a time of regular people working hard and families getting by the best they could. At the time of this late-1920s photograph, the national economy was already careening toward collapse, and a citywide property tax strike gave Chicago a head-start-plummet into the dark decade to come. Those who could, those who saw ahead, those with means, sold their stocks early enough to avoid the worst. But many who labored for a living, people like this family in Rogers Park, had little defense against the impending turn of the economic tide. (Courtesy of RP/WR HS.)

Six

THE GREAT DEPRESSION

I see one third of a nation ill-housed, ill-clad, ill-nourished.

—Franklin Delano Roosevelt

When the stock market crash of 1929 hit, Chicago was already in the throes of an economic crisis, resulting from a tax strike the previous year that had put the city near bankruptcy. The crash was gasoline to the fire. Confidence in the stock market plummeted. Many lost their jobs, and some who retained employment saw wage cuts of 60 percent. When banks closed, many depositors lost their life savings. Jules Gershon, a boy at the time of the crash, recalled the suicide jumpers in Chicago's Loop: "It didn't just happen on Wall Street." Pres. Herbert Hoover's term ended in 1933, followed by Franklin Delano Roosevelt, who introduced the New Deal to pull America from the throes of collapse. Still, the darkest days of the Depression came during the winter of 1933–1934. Only afterwards, did the Works Progress Administration (WPA) begin to mitigate the crisis by providing jobs to the jobless.

The Depression brought the age of decadence in Rogers Park to a screeching halt. The Phillip State Bank closed due to lack of funds. The Birchwood Country Club shut its doors. Development, begun in the 1920s, limped along for a while before petering out.

As with the rest of the nation, people hinged their hopes on entertainment, and Rogers Park's grand theaters remained open. During this time, many young Rogers Parkers delved headlong into arts and entertainment of all kinds, including the young puppeteer Burr Tillstrom and future bestselling author Sidney Sheldon. "I lived with my family in a small, third-floor apartment in Rogers Park," wrote Sheldon in *The Other Side of Me*. "The great showman Mike Todd said that he was often broke but he never felt poor. I, however, felt poor all the time because we were living in the demeaning kind of grinding poverty where, in a freezing winter, you had to keep the radiator off to save money and you learned to turn the lights out when not in use. You squeezed the last drops out of the ketchup bottle and the last dab of toothpaste out of the tube."

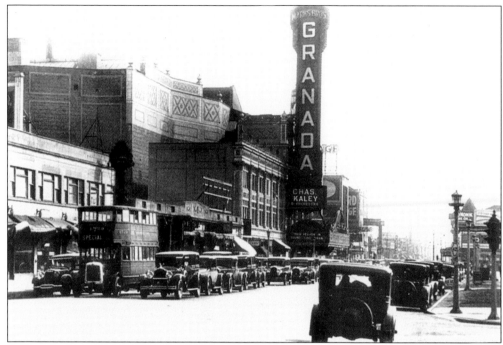

During the Depression, Rogers Park's theaters remained open, providing inexpensive solace to an ever-depressed public. Hershel Oliff recalls, "During the Depression a picture cost ten cents and popcorn cost five. My father gave me a quarter to go to the movies. When I got home, he said 'Where's my dime?'" (Courtesy of RP/WR HS.)

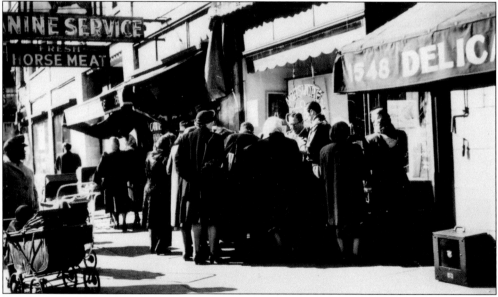

Here Rogers Park residents line up at Canine Service to buy horse meat, which was usually fed to dogs. Unable to afford beef, many Americans resorted to horse meat as a protein substitute from the Depression through World War II. Some Rogers Park families, like that of Sullivan graduate Jules Gershon, were more fortunate. But other families were not so lucky: "I remember two, sometimes three families living in the same place," he recalled. (Courtesy of RP/WR HS.)

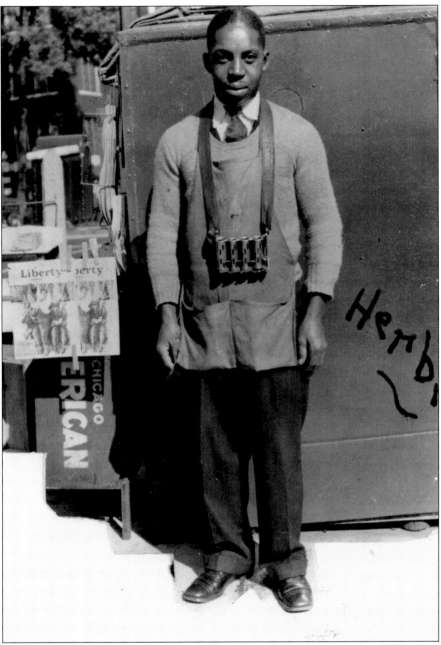

Here Herbert Williams sells *Liberty Magazine* and the *Chicago American* newspaper at his newsstand on the corner of Rogers Avenue and Sheridan Road. It is 1933, little more than a decade from the year that Rogers Park's own Fritz Pollard Sr. became the first African American NFL coach. In that decade, the NFL segregated and forced out one of its finest athletes. At the time, segregation laws plagued both north and south, and Chicago was no exception. The Great Depression is difficult for people now to comprehend; at its peak, one in four Americans was jobless. Chicago's minority citizens, African Americans and Latinos, fared much worse, at some point enduring unemployment rates of 50 percent. But Williams's newsstand survived. He sold papers on this corner for five decades and became a neighborhood institution. (Courtesy of RP/WR HS.)

Rogers Park's rapid population growth in the 1920s created a serious demand for more public schools. Sullivan Junior High School opened its doors in 1926, and became Sullivan High School by 1930, Rogers Park's only public high school. Prior to that, neighborhood students went to Senn High School in Edgewater. (Courtesy of RP/WR HS.)

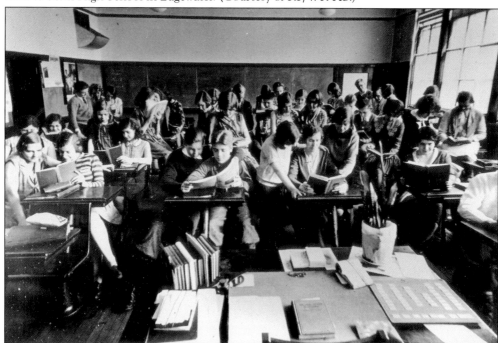

By 1933, Chicago public school teachers were owed almost nine months of back pay, but Rogers Park's schools remained open. This 1930s Sullivan High School classroom appears refreshingly relaxed, an oasis from the outside world. Students and teachers invariably found many ways to relieve stress. Shecky Greenfield, known best as world-class comedian Shecky Greene, developed his early comic chops within the walls of Great Depression–era Sullivan. (Courtesy of RP/WR HS.)

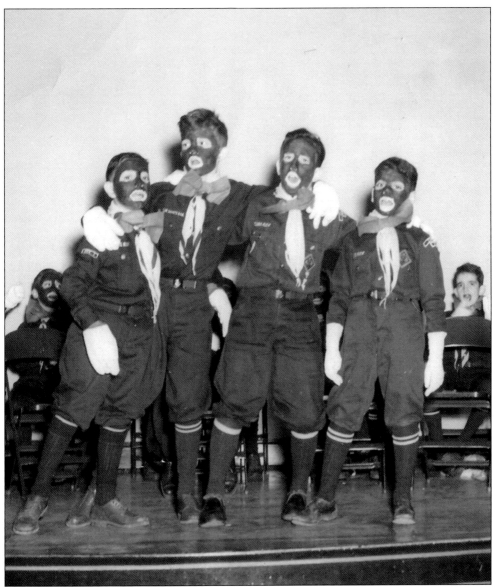

Minstrel shows were not uncommon in Rogers Park. Here a Rogers Park Boy Scout troop performs in blackface. Sullivan High School and Stephen Francis Gale Elementary School, north of Howard Street, also gave minstrel shows throughout this era. The minstrel show, where whites blackened their faces and performed sketches that mimicked African Americans, became hugely popular before the Civil War, when black men could not appear on stage. They hit a revival in the late 1920s, when Al Jolson's *The Jazz Singer*, the first talking picture, swept the nation and received a special Academy Award. Actors like Judy Garland and Bing Crosby later appeared in films in blackface, and the original Amos and Andy were white actors who performed in blackface. Even African American Bert Williams did shows in blackface. One of the most damaging effects of the minstrel show is that they perpetuated negative stereotypes about African Americans. The minstrel show remained popular into the 1950s, when African Americans began to exert a stronger influence on society and in politics, and social consciousness began to shift as the civil rights movement took root. (Courtesy of RP/WR HS.)

Three days after the stock market crash that caused the Great Depression, Sr. Mary Justitia Coffey and Mother Mary Isabella Kane, at the request of George William Mundelein, then cardinal of Chicago, presided over the groundbreaking of the world's first skyscraper college for women. The gorgeous, 15-story art deco building, named in the cardinal's honor, opened to a class of 400 students in September 1930. At 198 feet high, the maximum height permitted by law in 1929, it towered over the campus of Loyola University. Pope Pius XI, quoted in the *Chicago Daily Tribune* in 1931, praised the college, saying, "I don't know that it is the greatest college in the world, but I am sure it is the one nearest heaven." Today the building is known as Loyola University Chicago's Mundelein Center (Mundelein was affiliated with Loyola in 1991). Now an official Chicago landmark, it is listed on the National Register of Historic Places. (Courtesy of Mundelein College Records, Women and Leadership Archives, Loyola University Chicago.)

Two colossal statues adorn the southern entrance of the Mundelein Center. On the left, holding the planet earth in his right hand is Jophiel, whose name means "beauty of God." On the right, holding the Book of Wisdom and pointing to a cross 150 feet above, is Uriel, meaning "light of God." The angels have remained intact to the present day. (Courtesy of Mundelein College Records, Women and Leadership Archives, Loyola University Chicago.)

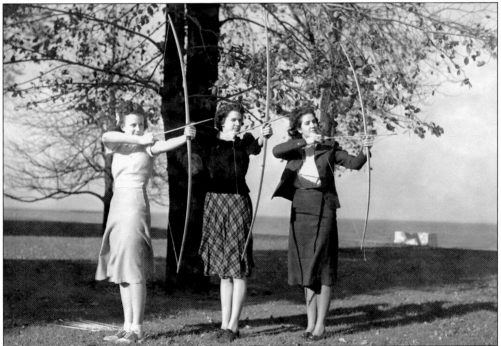

In addition to rigorous academics, Mundelein College offered young women in the 1930s a wealth of other opportunities including a music library, a greenhouse, and opportunities to participate in a variety of sports programs. Catherine Gould Roche, studio director at WGN, led a radio broadcasting class that was the first of its kind in Chicago. (Courtesy of Mundelein College Records, Women and Leadership Archives, Loyola University Chicago.)

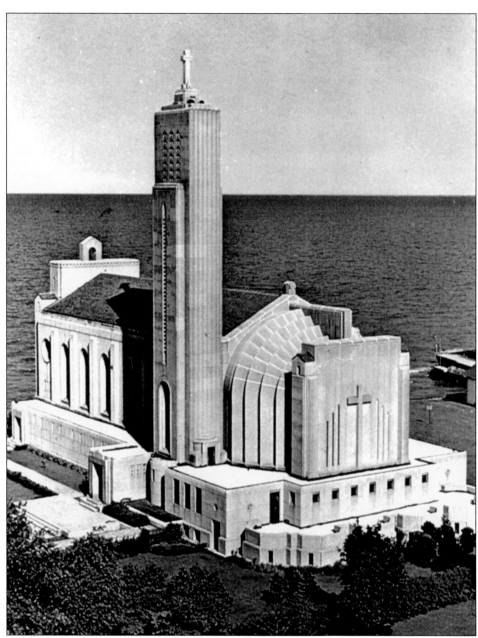

Loyola's Madonna della Strada Chapel (the "poem in stone") was the second art deco masterpiece for Rogers Park. Despite the limited economic reserves during the Great Depression, longtime Loyola classics professor James J. Mertz, SJ, organized fund-raising campaigns and netted $700,000 for the project. Construction began in 1938. Like other art deco buildings of its day, the chapel plan was influenced by cubism, futurism, and constructivism as well as design ideas from ancient Egypt, Assyria, and Persia. At the time it was built, it was assumed that Lake Shore Drive would be extended through the neighborhood, so the main entrance to the chapel was placed on the east side, opening directly onto the lake. In addition to his work fund-raising for the chapel, Mertz is also known for his six-decade-long teaching career and for championing Loyola's collection of Jesuit poetry. (Courtesy of Loyola University Chicago Archives.)

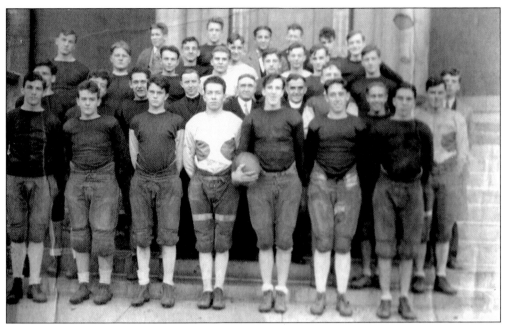

Before the 1920s, college athletic teams did not have names; they went only by their school colors. In 1925, Loyola University's football coach, perhaps tired of calling his team Maroon and Gold, held a contest to find a fighting name for Loyola. "Grandees" won, but it did not catch on. The football team traveled so extensively that the media dubbed them "the Ramblers." This accidental-turned-official name has far outlasted Loyola's football program, which was phased out in 1930. John "Jack" Dooley (above, second row from top, far right) played with the Loyola football team. Below, he relaxes with the poise of a cinema star on one of his many fishing trips. Dooley was a Rogers Parker through and through. He grew up in the neighborhood, was an early "Sam's Boy," and attended Loyola Academy followed by Loyola University. (Above, courtesy of Steve Dooley; below, courtesy of Genevieve Dooley.)

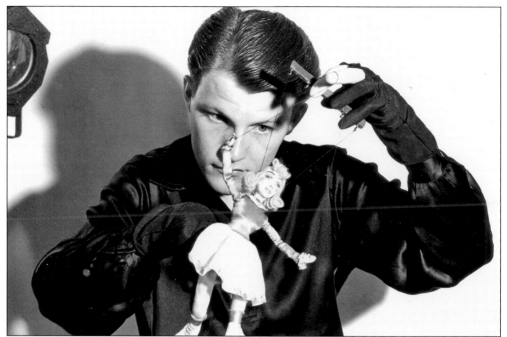

Burr Tillstrom, the creative talent behind the *Kukla, Fran and Ollie Show*, gave his first puppet performance in the window of his family's Rogers Park ground-floor apartment using teddy bears and borrowed dolls. Here is the young puppeteer in 1933, while a student at Senn High School. Tillstrom developed his early professional puppetry as part of Franklin Roosevelt's WPA, which provided employment during the Great Depression. (Courtesy of Richard Tillstrom.)

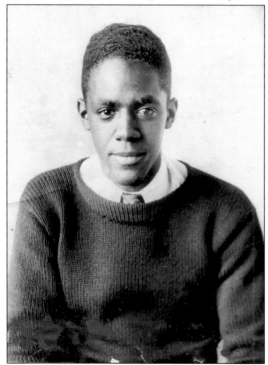

Frederick Douglass "Fritz" Pollard Jr. followed in his great father's athletic footsteps. Fritz Pollard Sr. had qualified for the Olympics in track and field in 1916, the same year he led Brown University to the Rose Bowl, but did not compete in the games. Frederick Pollard Jr. became the first member of the Pollard family to represent the United States, 20 years later at the 1936 Summer Games in Berlin. He won the bronze medal for the high hurdles. He is pictured here in a Senn High School photograph. (Courtesy of RP/WR HS, Pollard family collection.)

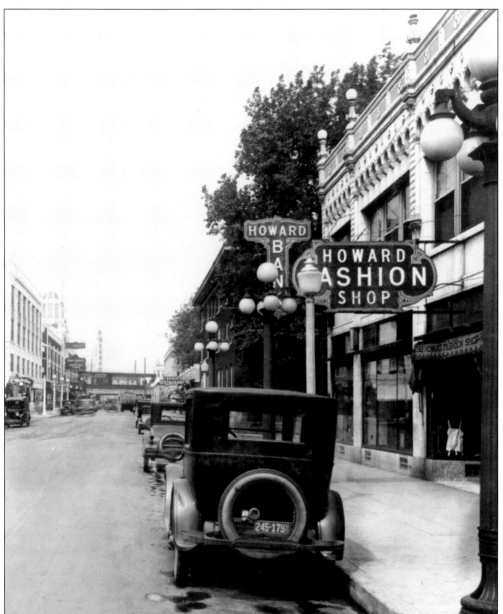

The moniker of Chicago's top street came from not a last name, but a first. In the 1860s, little Howard Ure played along a dirt path on his father John's dairy farm. When, in 1897, the elder Ure donated Howard's right-of-way to the city, developer Charles Ferguson named the street after young Howard. The camisole in the window of the Howard Fashion Shop may be a subtle glimpse to the vast jump between this sleepy early morning scene and the Howard Street of the evening—ladies may have shopped on Howard Street in the daytime, but at night, the hot-to-trots ruled the street. Not everyone appreciated the nightlife: "Young women cannot walk down Howard Street of an evening because of adventurous drunks who fast become a menace and an annoyance," wrote June Hill in 1935. "I am not one condemning men only. Such a condition breeds a hangout spot for women who have not been from conventional society. I have seen such women on Howard Street myself so I am not talking through my hat." (Courtesy of Chicago History Museum, ICHi-25860.)

For children in the late 1800s and early 1900s, Halloween meant a night of pranks like soaping windows, tipping over outhouses, and unhinging fence gates all of which was blamed on the rambunctiousness of fairies, elves, witches, and goblins. In the 1930s, as an alternative to vandalism, children were encouraged to go door-to-door and receive treats from homes and shop owners. The phrase *trick or treat* was first recorded by the Merriam-Webster Company in 1941, just a year before this photograph was taken. (Courtesy of RP/WR HS.)

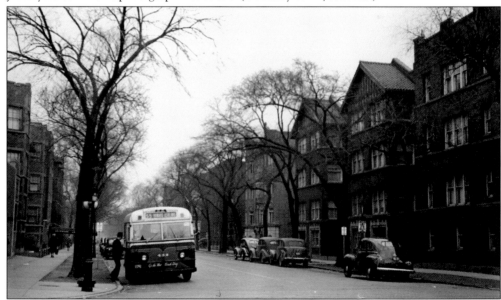

The American elm was considered the queen of trees throughout Chicago. Even in the cold weather months, its beautiful vase shape and canopy effect is obvious. The 1940s were the heyday for this tree as illustrated by this street scene looking north on Ashland Avenue at Pratt Boulevard. A decade later, many of the elms would be decimated by the fungal Dutch elm disease. (Courtesy of Chicago Transit Authority.)

As the 1930s drew to a close and the 1940s began, life in Rogers Park got a bit easier. Dressed in their Easter best, Cora Lee and Mary Lou Zender, daughters of John "Jack" Zender Sr. (page 59), admire the Easter lilies at their grandfather's florist shop at 1735 Howard Street. Other businesses on Howard Street included the North Shore National Bank (1737), the Limehouse, which was an exclusive restaurant with dancing and live orchestral music (1561), and Davidson's Bakery (1617). (Courtesy of John J. Zender Jr. collection.)

December 1941 started out as usual for Rogers Park; there was ice-skating at Touhy Avenue Beach and enough snow to grab the sleds. On December 7, however, everything changed. Neighbors listened with horror as the radio announced Japan's attack on Pearl Harbor. The next day, the U.S. Congress declared war on Japan. This 1940s photograph was snapped in front of a fish market that would later be home to Heartland Café. (Courtesy of Michael James.)

In an address to a joint session of Congress, President Roosevelt called December 7, 1941, "a date which will live in infamy." On December 9, the *Rogers Park News* ran the headline, "War Hits Northside" and noted, "The Northside was put on a war basis Monday following Japan's . . . attack . . . with two-man details on 24-hour duty assigned to guard Commonwealth Edison plants, telephone company offices, pumping stations, post offices and Peoples Gas tanks." (Courtesy of RP/WR HS.)

At age 31, John "Jack" Dooley had passed the official age of the draft when, in 1942, he enlisted in the U.S. Coast Guard. While posted on the USS *Murzim* in the Pacific Theater, Dooley met a lifelong friend, *Roots* author Alex Haley. Haley discovered a talent for writing at sea, offering to write love letters to shipmates' sweethearts. He charged a dollar per letter. "A lot of marriages came out of my love letters," Haley once said. (Courtesy of Steve Dooley.)

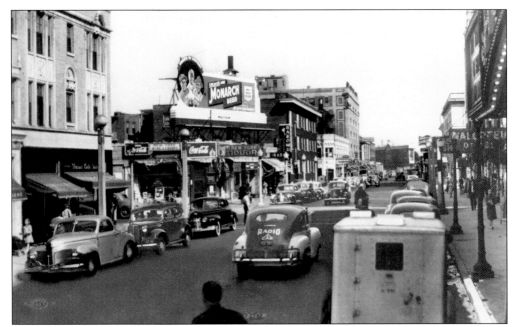

During the war years, Howard Street had grown up from its heyday of the 1920s into a mature bustling metropolitan thoroughfare, where anything was possible during the day and everything at night. It was a time when Club Silhouette featured the smooth voice of Sarah Vaughan. This vantage point is looking east, a few doors down from the Howard Street L. The grand Howard Theater marquee kisses the frame to the right. (Courtesy of RP/WR HS.)

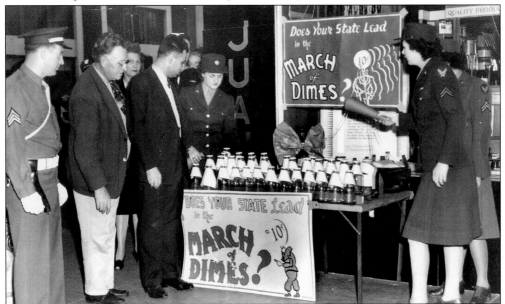

The U.S. Army Nurse Corps collects for the March of Dimes in an effort to combat polio. An idea born from Roosevelt, who suffered lifelong paralysis following a bout with the disease, the March of Dimes began as the National Foundation. Funnyman Eddie Cantor coined the phrase *March of Dimes* after a popular newsreel of the day, "March of Time." The comic successfully appealed to radio listeners across the nation to send their dimes to the White House. (Courtesy of RP/WR HS.)

Jules Gershon grew up near Estes Avenue and Sheridan Road. He enlisted in the navy during his senior year at Sullivan High School and shipped off to boot camp the day after graduation, 1944. On August 14, 1945, Gershon and his company were on a ship off the coast of New York when word came that Japan had surrendered. "We got off the boat and poured into Times Square," said Jules, whose face (at least much of it) was immortalized in the left frame of one of the most famous photographs of the 20th century, the *Life* magazine image of the sailor kissing a girl in Times Square. In the photograph, Gershon appears to be smiling at the smoochers. "I have a vague recollection of the photograph being taken," he said. Seen here is the *Life* magazine special edition from the fall of 1990.

Toddling Peter Charles Winninger clings to his grandmother's hand as they pose for a photograph with Peter's uncle Kirk, back from the war in 1945. The Winningers, a five-generation Rogers Park family, have seen more than one war; Peter would tour Vietnam 20 years after this photograph. For now though, he, along with his family, will fight the war on the home front, conserving resources and materials in an effort to support the military. In 1942, food rationing, instituted on a nationwide level, regulated the quantities of commodities Americans could purchase, and the challenge fell to the mother to budget ration stamps and plan meals. If a ration book disappeared, it was a major loss. Items taken for granted in today's society, such as butter, sugar, coffee, were rationed during the war years, as were clothing, shoes, gasoline, tires, and fuel oil. (Courtesy of Peter Winninger Jr.)

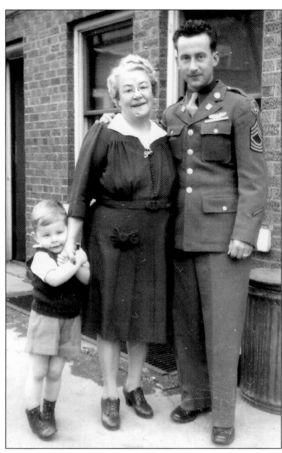

738948 EJ

UNITED STATES OF AMERICA
OFFICE OF PRICE ADMINISTRATION

WAR RATION BOOK TWO

IDENTIFICATION

Peter Charles Winninger
(Name of person to whom book is issued)

OFFICE
OF
PRICE ADM.

R-123

1624 Morse Ave
(Street number or rural route)

Chicago _____ *Illinois* _____ 16mo. M. 738948EJ
(City or post office) _____ (State) _____ (Age) (Sex)

ISSUED BY LOCAL BOARD No. *40-49* *Cook* _____ *Illinois*
(County) _____ (State)

7019 N. Ashland _____ *Chicago*
(Street address of local board) _____ (City)

By *Ellen R. Johnson*
(Signature of issuing officer)

SIGNATURE *Peter Charles Winninger*

(To be signed by the person to whom this book is issued. If such person is unable to sign because of age or incapacity, another may sign in his behalf)

WARNING

1 This book is the property of the United States Government. It is unlawful to sell or give it to any other person or to use it or permit anyone else to use it, except to obtain rationed goods for the person to whom it was issued.

Victory in war meant that enlisted men could serve out their time dreaming of pretty women and smoking cigars. America was in a celebratory mood, and there was revelry in Times Square and throughout the nation. In Rogers Park, families were anxious to welcome their soldiers back home. (Courtesy of RP/WR HS.)

Martin J. (Marty) Schmidt was a member of the Army Pictorial Service Signal Corps during World War II. Postwar, as a free-lance photographer, he went on to a prolific decades-long career and made great contributions to the collection of the Rogers Park/West Ridge Historical Society, restoring thousands of vintage images and shooting documentary photography. His work appears in the collections of the Chicago History Museum and in publications like *A Selection of the World's Greatest Photographs* by the Editors of Photography Magazine. (Courtesy of Martin J. Schmidt.)

Seven

TELEVISION AND APPLE PIE

It was a mean time. The nation was ready for witch-hunts. We had come out of World War Two stronger and more powerful and more affluent that ever before, but the rest of the world, alien and unsettling, seemed to press closer now than many Americans wanted it to.

—David Halberstam

With World War II at an end and the United States growing into its position as a superpower, Americans relaxed in a way not possible before. They welcomed the chance to work at good jobs for better wages and find new ways to have fun and spend money. This was the time of the GI Bill and the American dream of moving away from the city into the more peaceful suburbs. The wealth of the earlier decades had moved farther north and west, and Rogers Park, now a mature neighborhood, experienced a building boom that filled almost all of the remaining available land. It was a good place for working class folks to raise a family. It was also a time when African Americans began to move into Rogers Park, although it would take another 20 years for some community organizations to formally extend an invitation.

Television altered the landscape of the American family. Between 1950 and 1955, the number of television sets in America increased by nearly 30 million. Shows like *I Love Lucy* and *Leave it to Beaver* were extremely popular, and Rogers Park native Burr Tillstrom became an early force in children's television programming.

Despite bobby socks, sock hops, and happy appearances, it was also a time of the Korean War and the Cold War. Fear of nuclear attack brought tension, and the U.S. Army constructed antiaircraft defenses throughout the Chicago area. A small army site with a 120 millimeter AAA (Anti Aircraft Artillery) battalion was temporarily housed at Loyola Park during this time. The battalion was eventually transferred to Fort Sheridan for training on the new Nike Ajax missile systems.

In 1947, when the *Kukla, Fran and Ollie Show* debuted on television, Burr Tillstrom lived at 1407 West Sherwin Avenue in Rogers Park with his father and mother, Burt and Alice. His daily routine was to have breakfast and lunch at home with his parents before heading to the studio at 3:00 p.m. to plan and then perform the live evening show. (Courtesy of Richard Tillstrom.)

The Old West was popular with young children in the 1950s. John and Tom Dooley went west, all the way to Indian Boundary Park in this 1954 photograph, wearing the shoot-'em-up garb made popular by movie and television shows of the era. "Since they were west of Rogers Park they thought it would be a fine place to wear their cowboy hats," said younger brother Dan Dooley. (Courtesy of Dan Dooley.)

The baby boom is on. In this 1948 photograph, baby Kang Chiu enjoys a stroll with grandfather Shing Moy, who ran a laundry on the 6900 block of Glenwood Avenue. Chiu's grandfather moved to Rogers Park in the 1920s, at a time when the neighborhood's building boom and thriving economy meant a high demand for service-oriented businesses. Chiu's parents also took up the laundry business. (Courtesy of Kang Chiu.)

Chiu (far right) plays in his parents' business, Publix Laundry on the 6800 block of Sheridan Road, just south of Farwell Avenue, with his brother Jerry (far left), sister Norine (second from left), and cousin Kwok. By the early 1950s, with the nation's population skyrocketing, families like the Chius looked for more space. In 1956, they bought a house at 6800 block of North Wayne Avenue, the site of the famed 1909 Cleminson murder (page 41). Chiu, a computer professional with a Ph.D. in immunology, raised his own family in the house on Wayne Avenue and lives there today. (Courtesy of Kang Chiu.)

In postwar migration to better neighborhoods and single-family homes, many Jews left their west side homes for the higher status of Rogers Park. Between 1930 and 1960, the Jewish population in Rogers Park more than doubled. At its height, it reached about 22,000. Jews constituted the largest ethnic group in the area and made up over a third of the community's population. Pictured here are Sarah Damask Wagner and her daughter Karen Wagner Tipp. (Courtesy of Karen Tipp.)

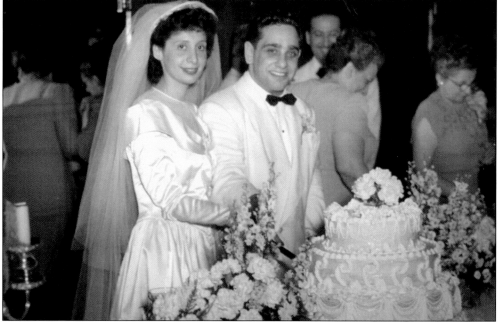

By the late 1940s, Rogers Park had several synagogues, a very active Jewish community center, and numerous cultural, educational, and social service organizations and institutions. For newly married Hershel Oliff, who had grown up in Rogers Park, there was no better place to settle down and start a family with his wife Adelle Rossin. (Courtesy of Hershel Oliff.)

Congregation B'nai Zion played a central role in the life of Conservative Jews. Not only was it a place to celebrate the High Holidays, it also offered Hebrew classes to the many Jewish children in the neighborhood. In 1946, Sullivan High School, located just blocks away from B'nai Zion, had approximately 2,000 Jewish students. By 1965, Jewish students would make up 85 percent of the public school's student population. (Courtesy of RP/WR HS.)

Shopping areas, restaurants, and delicatessens catered to the area's large Jewish population. Lines would often form outside of Ashkenaz Restaurant, at 1432 West Morse Avenue, where one could get traditional favorites like corned beef, salami, and pastrami on rye. Ashkenaz was one of Chicago's largest Jewish delicatessens and served more than one half ton of corned beef each month. (Courtesy of RP/WR HS.)

Enjoying the beach was always part of life in Rogers Park, so it came as a shock when the community learned in 1952 that developers planned to build high rises at 13 street-end beaches along the lakefront. To prevent this from taking place, community members, led by Tobey Prinz (pictured standing), Charlotte Goldberg, and other community residents, started a campaign to save the beaches, asking the City of Chicago to purchase the street-end beaches. (Courtesy of Rogers Park Community Council.)

When no answer came, they initiated the Bags of Sand Campaign. Neighbors mailed hundreds of bags of sand to Mayor Richard J. Daley. It took more than eight years, but in the end, the city acquired all 13 lots. In 1959, these were transferred to the Chicago Park District. For young Dan Dooley (at right), and scores of kids through the decades, the open beaches were a place to gather and play, and to create a lifetime of memories. (Courtesy of Dan Dooley.)

Most of the small parks and playgrounds in Rogers Park were developed in the 1920s, but Touhy Park got its start in the years after World War II. The postwar housing and population boom created a desperate need for open space. Urged by neighborhood residents, the Chicago Park District created Touhy Park in 1948, on land where Capt. Patrick Leonard Touhy's house sat in the 1800s. (Permission and courtesy of Chicago Park District Special Collections.)

John Fitzgerald, a life-long Rogers Park resident, remembers his childhood days in the mid-1950s: "As young kids we roamed the area afoot or on bike. We felt like we owned the neighborhood and that, somehow, the adults were looking after our welfare. Safety was never an issue." (Courtesy of RP/WR HS.)

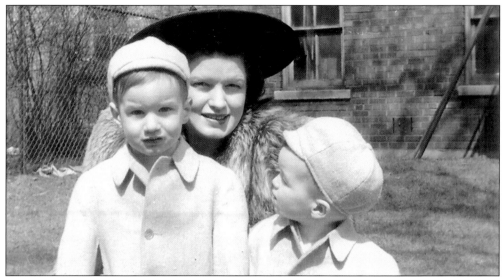

Genevieve Dooley celebrates Easter in 1953 with sons John and Tom, dressed in typical Marshall Field's boys' clothes from the period, in their backyard at 1430 West Pratt Boulevard. Genevieve, a driving force in renaming Rogers Park and Beach (at Touhy Avenue and the lake) in honor of Sam Leone following the beloved lifeguard's death in 1965, said, "If any of the young people had a problem, he would help them to believe in themselves again. Too bad we don't have another Sam Leone." (Courtesy of Dan Dooley.)

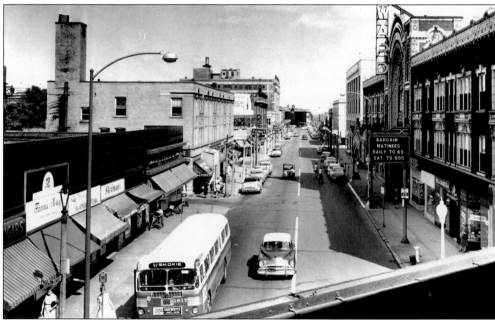

Now considered an old neighborhood, Rogers Park moved past its wild days and settled well into the popular notion of the 1950s—family-friendly—with all the commercial trappings. "Dumke Radio sold the first televisions sets to Rogers Parkers," said Sandy Goldman. "Women bought dresses from Kay Campbell, Stolman's or Loretta Kam. Their husbands could shop at Tuckers Store for Men. For the children they would go to Howard Juvenile." There was something for everyone. (Courtesy of RP/WR HS.)

Jacquelyn "Jackie" Klein Fie began her Olympic career as a gymnast and went on to carve out a five-decade legacy as an administrator, coach, technical official, and Olympic judge. Klein grew up on the 6400 block of Bosworth Avenue, and began the development of her athletic skills during her elementary school years at St. Ignatius. She attended Northwestern University (B.S. 1959), training at the American Turners and the Chicago Park District, because at the time Northwestern University did not offer women's training and competitive facilities. (Courtesy of Jacquelyn Klein Fie.)

In the 1956 Melbourne Olympic Games, Jackie represented the United States as a member of the Women's Olympic Gymnastic Team. A back injury forced her early retirement from competition. She went on to be the most influential judge in the history of gymnastics, serving at 10 Olympic Games. Upon her 2004 retirement, USA Gymnastics's magazine *Technique* called her the "First Lady of Gymnastics." Of her childhood in Rogers Park, Jackie said, "One of my best memories was performing in the St. Ignatius 'Salute to Youth' program. The Teen-Age Club members put on this annual St. Patrick's musical, an original variety of song, dance and skits. We were very fortunate to live in such an active parish in the community of Rogers Park." (Courtesy of Jacquelyn Klein Fie.)

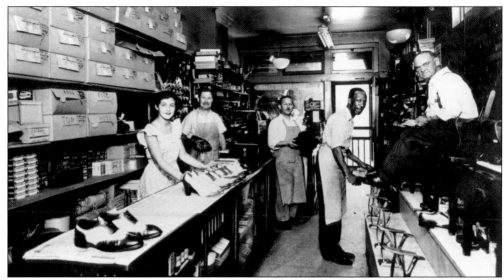

The brutal 1955 Mississippi lynching of 14-year-old Chicago resident Emmett Till marked a turning point in the civil rights movement. Although progressive compared to the Deep South, Chicago remained a segregated city, and in places like the Irish-dominated southwest side, police looked on as crosses burned. But even in "friendly-to-all" 1950s Rogers Park, blacks felt the sting of discrimination—from shakedowns by the cops, to a sad kind of invisibility. (Courtesy of RP/WR HS.)

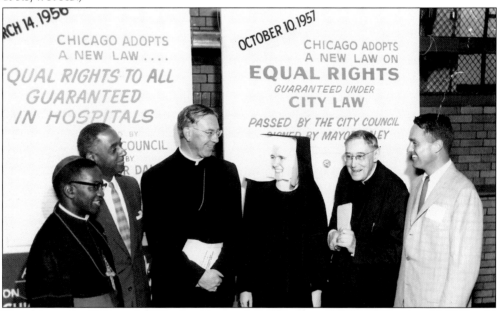

Throughout the 1940s and 1950s, the Chicago-based Congress for Racial Equality (CORE) told the world, "Change is coming." In 1954, *Brown v. Board of Education* ended school segregation, and the next year Rosa Parks altered history by refusing to move to the back of the bus in Alabama. In Rogers Park, lifelong equal rights activist Sr. Ann Ida Gannon (center) became president of progressive Mundelein College. In October 1958, Mundelein cohosted the first National Conference for Interracial Justice with, among many organizers, Sargent Shriver (far right). (Courtesy of Mundelein College Records, Women and Leadership Archives, Loyola University Chicago.)

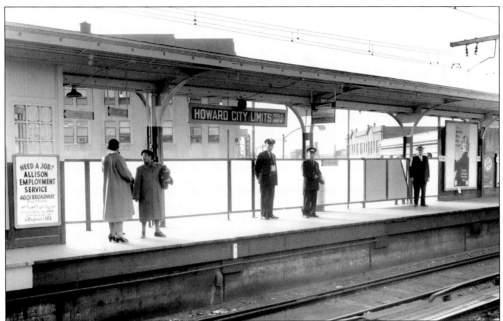

These scenes, on the north side of the Howard Street L, divide the pair of women above and below by a mere 20 feet, but their worlds couldn't have been further apart. The civil rights movement was taking hold, and in places like Little Rock, Arkansas, students took center stage, desegregating schools despite often-violent opposition. In Montgomery, a 13-month bus boycott by African American citizens, led by a young minister named Dr. Martin Luther King Jr., did serious damage to the city's revenue. In Rogers Park, even though African Americans worked in local businesses, few black families actually lived in the neighborhood. Census data from 1960 shows that Rogers Park was 99.3 percent white. In the 1960s, a group of conscientious Rogers Park citizens, the Rogers Park Community Council, would take steps to change that. (Above, courtesy of Chicago Transit Authority; below, courtesy of Evanston Historical Society.)

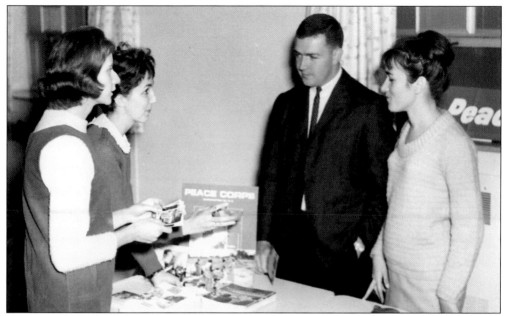

In 1961, at the dawn of the founding of the Peace Corps, Mundelein students were signing up and ready to work. Established by Pres. John F. Kennedy as a federal agency "designed to promote mutual understanding between Americans and the outside world," the Peace Corps was right in step with Mundelein's progressive activist paradigm. (Courtesy of Mundelein College Records, Women and Leadership Archives, Loyola University Chicago.)

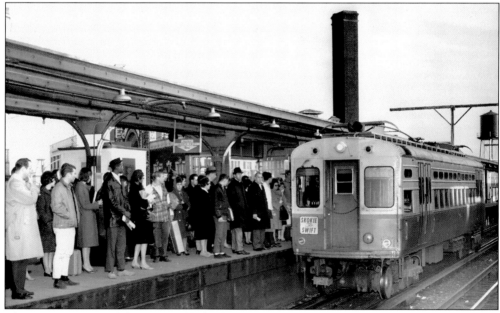

The year is 1964, and this is very likely the inauguration day for the Skokie Swift, a five-mile one-stop "shuttle" train from Howard Street to Skokie. This federally aided experiment in a mass transit project attracted nationwide attention, and the first day's run carried 4,000 passengers back and forth between Chicago and Skokie. As more city residents relocated to the surrounding towns, mass transit became a suburban concern. (Courtesy of Chicago Transit Authority.)

Eight

GREAT STRUGGLES, GREAT STRIDES

Rogers Park has enjoyed the privilege of a long history as a harmonious community of people representing all races, cultures, and religious traditions. . . . We believe that welcoming all new residents to the community, whatever their diverse backgrounds, is in keeping with the American tradition and is basic to the ultimate good of this community.

—Rogers Park Community Council, 1963

Today Rogers Park looks very much like the planet Earth rolled into one neighborhood, but in the early 1960s, the community was predominantly white, and few residents wanted integration. The Rogers Park Community Council had a different vision. In an open letter, dated October 1963, they unlocked the door to the neighborhood, and soon the people of the world began to arrive.

As Rogers Park entered the 1960s, the black struggle for civil rights had grown from a campaign of civil disobedience in the south to a nationwide crusade for equality, and the war in Vietnam was already escalating into a military nightmare. The decade saw the assassinations of five important Americans; John F. Kennedy, Medgar Evers, Dr. Martin Luther King Jr., Robert F. Kennedy, and Malcolm X. Students were more organized than ever before. Young men and women, known as freedom riders, crammed onto buses, whites in back and blacks in front. The Students for a Democratic Society (SDS), the New Left, led the antiwar movement.

In Rogers Park, the movement made its mark. The Loyola Ramblers basketball team championed integration by starting four, even five, black players. Several women from Mundelein College joined the march in Selma to stand for civil rights. Sr. Ann Ida Gannon served on Pres. Richard Nixon's task force for equal rights. Michael James, active in the SDS, worked to organize the poor and to raise the consciousness of American youth.

Times were changing, and Rogers Park was changing too.

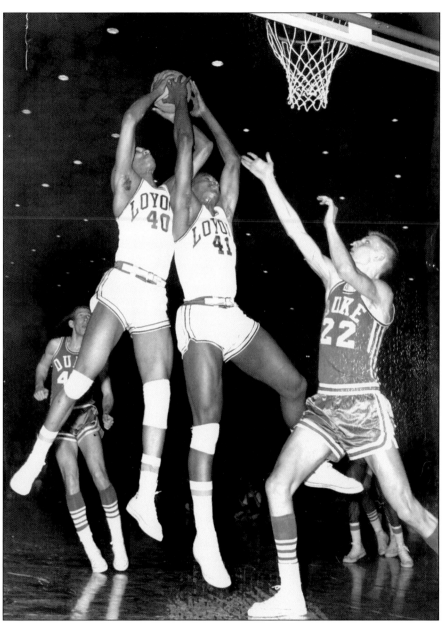

It is one thing to win a basketball championship game, yet quite another to become the people's representative. Loyola's basketball team did both in 1963. A gentleman's agreement among collegiate teams limited the number of black players in a game. Head coach George Ireland broke this unofficial rule, fielding four black starters in 1963 and devouring the competition, winning round one of the national tournament. Ireland's decision enraged Mississippi governor Ross R. Barnett, who banned the Mississippi team from traveling to the tournament to play round two. The Mississippi State University team, however, successfully evaded the state police, and in an event that ESPN deemed "One of the 25 most defining moments in NCAA history," Mississippi State's all-white team battled Loyola and lost. Loyola then beat the University of Illinois in its regional final and Duke in the national semifinals. (Courtesy of Loyola University Chicago Archives.)

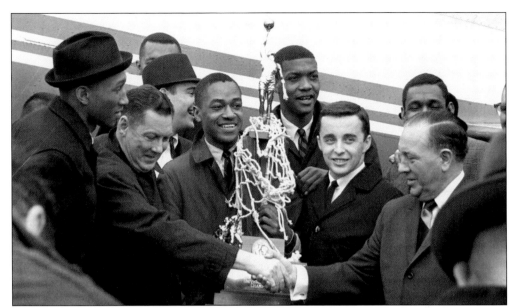

Newspapers reported that the Loyola Ramblers did not have a chance against Cincinnati, the two-time defending national champions. Loyola forced the Bearcats into overtime, scoring the final basket as the buzzer sounded and winning the national championship 60-58. Loyola became the first and only team in Chicago, and in the state of Illinois, to win the NCAA Men's Division I Basketball Championship. (Courtesy of Loyola University Chicago Archives; photograph by Thomas J. Dyba.)

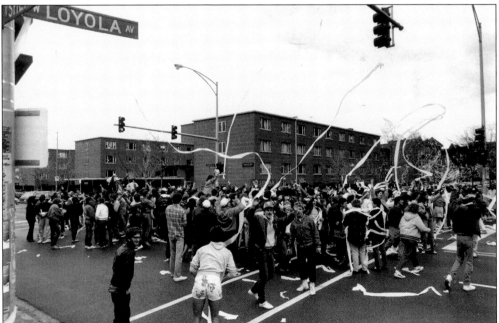

On March 24, 1963, the *Chicago Tribune* headline read, "Loyola Rules U.S." Rogers Park erupted into celebration. The Ramblers were not just champions of a division; they were champions of a cause. Their willingness to field black players at every game, despite a racially segregated country, changed attitudes on and off the court. (Courtesy of RP/WR HS.)

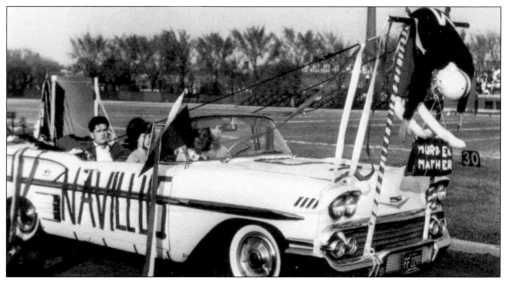

Girls and boys in a convertible, and the rival footballer hanging in effigy with the epithet "Murder Mather" is the quintessential prewar image of the 1960s. In 1964, Sullivan High School students wasted no time declaring West Ridge's Stephen T. Mather High School, founded just four years prior, a mortal enemy on the football field. "Navillus," splayed across the side of the car, is "Sullivan" spelled backward. (Courtesy of Karen Tipp.)

Rock and roll is here to stay. These teens from Rogers Park's Temple Mizpah entertain the crowd as part of the Hi Neighbor Day Parade in October 1964. The previous month, the Beatles played Chicago, and the Hi Neighbor Day event featured more than one kid with a guitar. The temple was the primary house of worship for Reform Jews in the area until 1977, when it relocated to Skokie. (Courtesy of Rogers Park Community Council.)

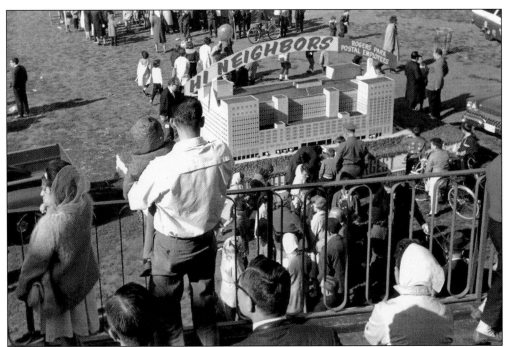

Hi Neighbor Day was a long tradition in Rogers Park, a community festival open to everyone who wished to attend. Sandy Goldman, a half-century resident of Rogers Park and former president of the Rogers Park Community Council, called the Hi Neighbor Day Parade, "The best community parade on the North Side. People watched from both sides of Sheridan Road waving to the school kids—excited little ones and blasé teenagers—who rode on floats or walked on foot. I'm not sure who was more proud, the parents or the kids, or who had more fun." This Hi Neighbor Day celebration, in 1964, came at a time of great national tension. Just two months earlier, the Gulf of Tonkin incident prompted the U.S. Senate to pass a resolution supporting Pres. Lyndon Johnson's efforts to escalate the war in Vietnam. (Courtesy of Rogers Park Community Council.)

The 1965 march on Montgomery brought about a turning point in the African American struggle for civil rights. The legendary "march" was actually three separate attempts. Spurred by brutal actions taken to prevent African American citizens of Selma, Alabama, from registering to vote, young civil rights worker John Lewis, now a U.S. congressman (D-GA), led 600 people out of Selma on Route 80 toward Montgomery. They made it six blocks, to Pettus Bridge, when police attacked them with billy clubs and bull whips. The day, well documented in the media, became known as Bloody Sunday. Dr. Martin Luther King Jr. immediately began organizing a second march, and across the nation, people mobilized—everyday citizens, prominent individuals, and a group of sisters and students from a small women's college in Rogers Park called Mundelein. (Courtesy of Mundelein College Records, Women and Leadership Archives, Loyola University Chicago.)

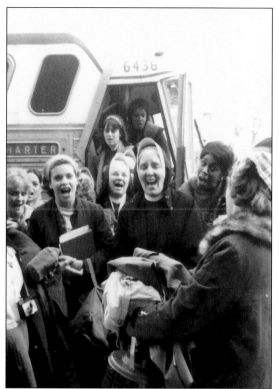

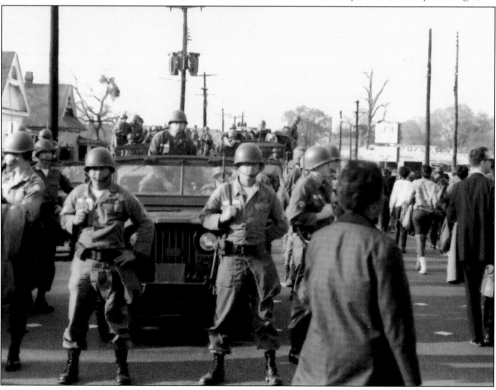

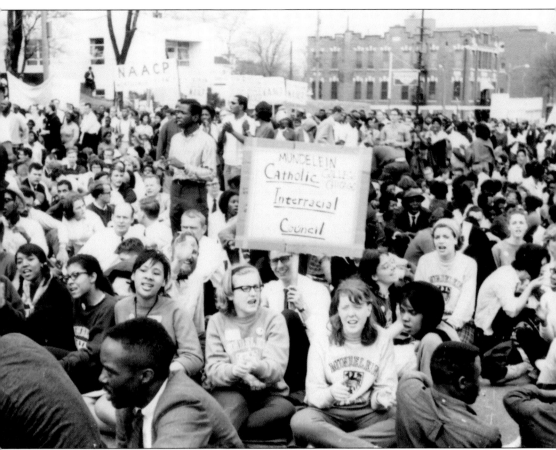

Barred by a court order, Dr. King led hundreds on March 9 to Alabama's Pettus Bridge, where he stopped and held a prayer vigil. Afterwards Dr. King obtained permission from a federal judge for a third march, scheduled for March 21. The sisters and students, determined to add their numbers to this very important moment in the struggle for rights of African Americans, boarded a bus to Montgomery, joining 25,000 people from across the nation, including entertainers Harry Belafonte, Sammy Davis Jr., Tony Bennett, and Peter, Paul and Mary, to march on Montgomery and hear Dr. King deliver his "How Long, Not Long" speech on the capitol steps. Gov. George Wallace did not greet the marchers. Five months later, Pres. Lyndon Johnson signed the Voting Rights Act, granting African Americans federal protection at the polls. (Courtesy of Mundelein College Records, Women and Leadership Archives, Loyola University Chicago.)

A decade before he opened the Heartland Café with Katy Hogan, Michael James (left) worked with American activist Tom Hayden as part of the SDS. Hayden, a founder of the SDS, played a key role in organizing the protests at the 1968 Democratic National Convention. His arrest, along with six others, including Abbie Hoffman and Jerry Rubin, pegged him as one of the "Chicago Seven." James's contribution to the youth activist movement included the leftist publication *Rising Up Angry*. (Courtesy of Michael James.)

James and Hogan opened the Heartland Café in 1976, and it quickly became a center for people of diverse backgrounds to share ideas and enjoy good wholesome food. Today the Heartland Café is a hotbed of Rogers Park progressivism and a gathering place for artists, thinkers, and everyday people. (Courtesy of Michael James.)

114

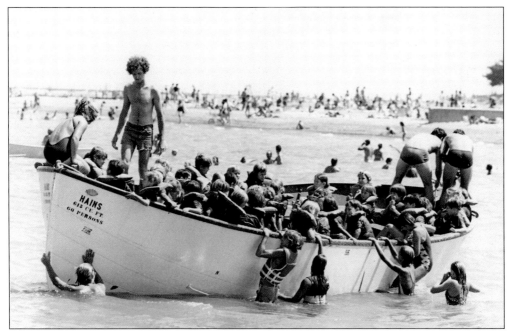

Now older, Dan Dooley (standing on boat) still spends summer days at the beach. For 40 years Sam Leone had supervised lifeguards, safeguarded swimmers, and counseled young residents of the neighborhood. In 1966, after a campaign by Rogers Park residents, the Chicago Park District renamed the site at Touhy Avenue and the lake, Leone Park and Beach in his honor. Leone's beloved "Sam's Boys," junior guard program, continued in his absence, admitting girls in 1970. (Permission and courtesy of Chicago Park District Special Collections.)

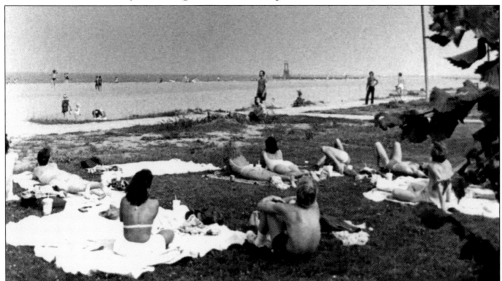

Rogers Park's lakefront is devoted to public purposes, accessible to all, free of charge, and the beaches, far from tourist traps, bring a familiar yet unique personality to the neighborhood. Leave the car at home—the best way to the beach in Rogers Park is to walk. This is a legacy from the hard-won Lakefront Protection Ordinance fought for by members of the Rogers Park Community Council. (Courtesy of RP/WR HS.)

Because of its lakeshore location, Rogers Park sometimes experiences strong winds and serious snow. Chicago's snowstorm of the century occurred in the winter of 1967, when 23 inches dropped in just 24 hours. The drifts reached up to six feet high. Cars and buses were stuck, but the trains continued to run. Accumulation from a 1979 winter storm was just one inch short of the 1967 mark. (Courtesy of RP/WR HS.)

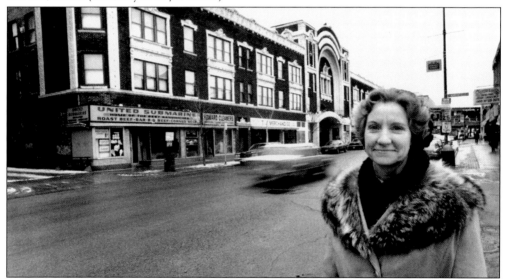

Mary Jo Doyle attended a meeting in July 1975 at the Rogers Park Library to help establish a local historical society, and spent the subsequent decades collecting photographs and artifacts. The organization was renamed the Rogers Park/West Ridge Historical Society in 1993, and Doyle has served as its executive director ever since. Her most oft-spoken words are, "Do you want to hear about our history," followed by, "Do you have any photos of the area?" (Courtesy of RP/WR HS.)

Nine

AN IMAGE OF AMERICA

*In Rogers Park a Palestinian, a Jew, a German, a Mexican, a Puerto Rican, an African American,
and a Japanese child can all be playing in the same sand box together, and their most
important concern is whether they will have this much fun tomorrow.*

—Peter Winninger Jr., also known as Pete Wolf

History may call the 1980s a "decade of magic" for Rogers Park, as it took on a new life as one
of Chicago's most eclectic neighborhoods—a virtual racial and ethnic potpourri, a haven for
immigrants and artists, a community that would come to represent 80 spoken languages. But
the reality of how the diversification of Rogers Park transpired, far from the ethereal, is rooted in
hardship, community action, and "white flight."

Aging buildings, rising crime, stunted development, Reaganomics—all meant difficult days
for low-income families. Throughout the neighborhood, residents worked for change. Heartland
Café cofounder Katy Hogan played an integral part in the 1987 reelection campaign of Harold
Washington, the first African American to hold the position of Chicago mayor. Organizations
like the Rogers Park Community Action Network, People's Housing, and the Howard Area
Community Center helped stabilize the community, fought for fair housing and increased wages,
and encouraged school safe zones and open spaces. Alderman David Orr (now Cook County
clerk), inspired by the principles of social justice, opened the neighborhood to scattered-site
public housing.

The result was a significant racial restructuring of the neighborhood. In one decade, the
neighborhood's African American population jumped by 212 percent, and the Latino American
population increased by 81 percent. Whites began fleeing to the suburbs. Whereas 99 percent
of the residents of Rogers Park had been white in 1960, by 1990, that number had dropped to
50 percent.

The improving national economy of the 1990s brought a new and contradictory situation—
gentrification. Condominiums went up in record numbers, and as rents increased, independent
businesses closed down, replaced by chain retailers and restaurants. The supply of affordable
housing waned.

Today Rogers Park is at a crossroads. Developers are tearing down much-loved buildings, rental
buildings are converting to condos, single-family homeowners fight to downzone to preserve their
blocks, and the poor community has become more and more alienated from those with means.

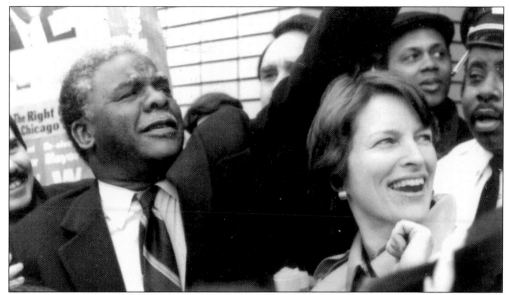

Heartland Café cofounder Katy Hogan (right) was one of the driving forces behind Mayor Harold Washington's 1987 campaign, serving as his north lakefront coordinator. Hailing from Chicago's "categorically racist" southwest side, Hogan came of age in the late 1960s, and the events of the day made a lifelong impact on her. Her decision to attend progressive Mundelein College stemmed from her desire to contribute to the movement for peace and equality. (Courtesy of Katy Hogan.)

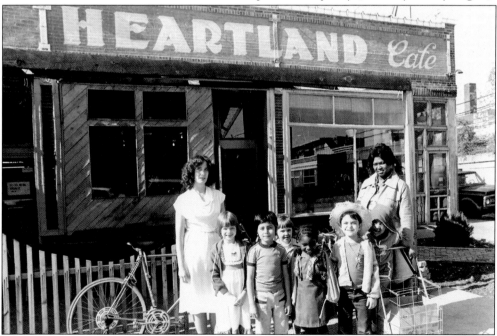

The Heartland Café's 30-year legacy is built on the healthy exchange of ideas, nourishing the body and mind, and celebrating the diversity of all peoples, from all walks of life, in Rogers Park and throughout society. "Without knowing it, we had started building an institution," said Hogan. Walk into the Heartland on any given day and one may encounter a political discussion, find an old friend, or make a new one. (Courtesy of Michael James.)

Kids will be kids. In this 1986 photograph, two Indian boys and one Mexican boy make off with a shopping cart. In play lots and sidewalks, homes and schools—whether behaving or misbehaving—Rogers Park's children of the 1980s grew up with an enlightened sense of racial consciousness. Here the big issue, rather than black, white, or brown, might be something like "run." (Courtesy of RP/WR HS.)

Lifelong Rogers Park resident Peter Winninger Jr. (top right) poses with his friends at the North Shore School on Birchwood Avenue. The school, on the site of the long-defunct Birchwood Country Club, provided students with a privileged education. In the 1980s, the time of this photograph, many neighborhood kids fell below the poverty line, and public school was their only option. (Courtesy of Peter Winninger Jr.)

While Chicago continues to be one of the nation's most segregated cities, Rogers Park is noted for its racial and ethnic diversity. Part of the credit for this goes to the many community organizations that work to sustain this diversity and to protect affordable housing. At the Howard Area Community Center, area youth work together on a community garden. (Courtesy of Howard Area Community Center.)

Today almost one third of Rogers Park's residents are of Latino origin, and most of that group is from Mexico. Clark Street has evolved into a growing corridor of Latino business. *Taquerias* line both sides of the street, *Mercados* offer bright-colored piñatas in addition to the regular grocery fare, and street vendors with pushcarts offer up tamales, *elotes*, and *horchata*. (Courtesy of Michael James.)

Religious diversity in Rogers Park is a benchmark of the community. The saffron-robed Hare Krishnas hold Sunday feasts open to all at their Lunt Avenue temple as, just blocks away, members of the Nigerian community, dressed in bright white, head to the Cherubim and Seraphim Church on Clark Street for Sunday service. Muslims, Sikhs, Hindus, atheists, agnostics, and New Age converts share the neighborhood with Jews, Protestants, and Roman Catholics. (Photograph by Gopasundari Devi Dasi.)

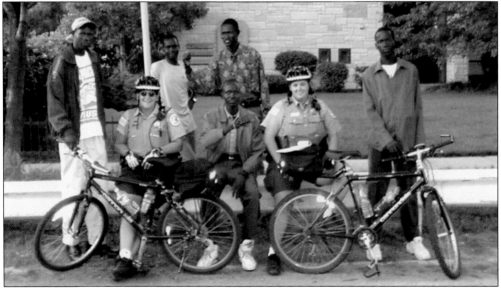

While other neighborhoods have closed ranks, Rogers Park continues to be a welcome haven for new immigrants, including many of the Lost Boys of Sudan. Fleeing the terrifying conditions of the Sudanese Civil War, these young boys walked for three months in search of safety. Over half were killed or captured. After 14 years in refugee camps, they found haven in the United States. (Courtesy of Ted Jindrich.)

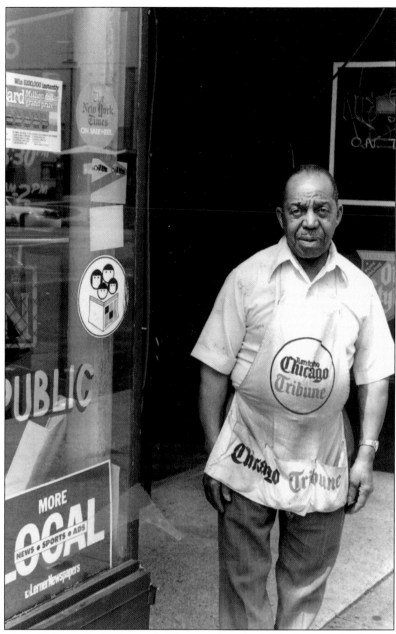

Here is Herbert Williams in 1982, nearly 50 years after the 1933 photograph taken on the same corner (page 79). Williams sold papers at Rogers Avenue and Sheridan Road through the Great Depression, three wars, and nine presidents, through the 1950s Montgomery, Alabama, bus boycotts, the freedom rides of the 1960s, and the Black Power movement of the 1970s. His voluntary acts of kindness resonate in memories to this day. As a boy in 1948, John Fitzgerald was one of many children "Herbie" would pick up and drive to school, at a time before schools provided bus service. Fitzgerald vividly recalls Williams singing "I'm a lonely little petunia in an onion patch" to amuse the kids during the ride. This photograph was taken around the time that rent gouging drove him out of business, ending his half-century run at this well-known intersection. (Courtesy of RP/WR HS.)

The 1990s marked a time of great change for Rogers Park. The dreaded words of gentrification and rent gouging loomed in low-income households that were barely getting by. Proposed developments prompted citizens to take to the streets. The Rogers Park Community Action Network, which has led a decades-long battle for affordable housing in the community, sponsored this demonstration. (Courtesy of Rogers Park Community Action Network.)

The loss of affordable housing stock challenged Rogers Park's poor and, as costs outstripped earning power for many, making ends meet became decidedly more difficult. Illegal drugs, joblessness, and thinning support networks exacerbated the problem and homelessness became more visible in the neighborhood. Crime and prostitution also increased leaving many in the community desperate and driving yet more middle-class whites to the suburbs. (Courtesy of Charlie Didrickson.)

Art and activism run parallel paths in Rogers Park, which has become a growing center for the arts in recent years, especially public art. Studios line Glenwood Avenue, murals decorate the train embankments, art festivals are held regularly throughout the summer, and this sculpture, by Lynn Takata, enlivens Pratt Boulevard Beach. Many famous artists call Rogers Park home, including the late Ed Paschke who had his studio on Howard Street, deemed the "Best Artist Chicago Produced" by the *Chicago Sun–Times*. (Courtesy of John Mikrut.)

Rogers Park emphasizes public space, community empowerment, and public discourse. People come together at the parks and beaches; they meet at restaurants, coffee shops, and outdoor cafés. Here there is a vibrant sense of community, rare among urban neighborhoods, a throwback to earlier days when people went outdoors to discover one another. (Courtesy of Charlie Didrickson.)

Today Rogers Park is an oasis on the edge of Chicago. When the Potawatomi fished from these beaches, what did they see when they turned their gaze southward? Trees? The flicker of firelight from camps along the lake? Or, like this modern-day view of downtown Chicago from Rogers Park, did it appear a land both distant yet connected? (Courtesy of Charlie Didrickson.)

The huge mansions and grand theaters of yesterday are mostly gone, but, for those who see wealth in diversity, Rogers Park remains the richest neighborhood in Chicago. This photograph of the Celebrate Clark Street festival captures the incredible mix of people who call Rogers Park home. It is the embodiment of a global community, truly an image of America. (Photograph by Jacque Day Archer.)

INDEX

Adelphi Theater, 61, 69
annexation, 28–32
Ashkenaz Restaurant and delicatessen, 99
Ashland Avenue, 22, 38, 50, 88
Black Hawk, 16
B'nai Zion, Congregation, 75, 99
Bags of Sand Campaign, 100
Birchwood Country Club, 52, 77, 119
Birchwood Depot, 22
Bosworth Avenue, 60, 103
Chicago, City of, 2, 18, 28, 100, 125
Chicago and North Western Railroad, 23, 33, 74
Chicago, Milwaukee and St. Paul Railway, 22, 36, 57
Chicago Transit Authority, 22
Chiu family, 97
Clark Street, 17, 23, 25, 26, 30, 32, 33, 34, 35, 44, 51, 52, 56, 69, 75, 120, 121, 125
Cleminson, Dr. Haldane, 41
Coffey, Sr. Mary Justitia, 82
Coughlin, Norm, 58, 60
Darbenfeld, Perry, 41
Devon Avenue, 8, 10, 52, 56, 62, 63, 68
Dooley, Dan, 96, 100
Dooley, Genevieve, 102
Dooley, John, 96, 102
Dooley, John "Jack," 85, 90
Dooley, Tom, 96, 102
Doyle, Mary Jo, 4, 116
Du Sable, Jean Baptiste Pointe, 10
Ebert tavern, Joseph, 26
Emil Bach House, 54, 55

Estes Avenue, 17, 23, 32, 92
Eugene Field School, 38
Fie, Jacquelyn "Jackie" Klein, 103
Fire of 1871, 21
Fitzgerald, John, 101, 122
Fort Dearborn, 14, 16
Fort Dearborn, Battle of, 14
Gannon, Sr. Ann Ida, 104, 107
Gershon, Jules, 77, 78, 92
Goldberg, Charlotte, 100
Goldman, Sandy, 102, 111
Granada Theater, 61, 67, 68, 78
Grant, Dorothy, 63
Green Bay Trail, 11, 19
Greenleaf Avenue, 23, 33, 73
Greene, Shecky, 80
Greenville, Treaty of, 11, 14
Hare Krishna temple, 121
Hayes Point, 37
Hayes Street station, 37
Heartland Café, 89, 114, 117, 118
Hermann Staerk's Horseshoer, 44
Hi Neighbor Day, 110, 111
Hickey, Mary Masterson, 17, 18
Hogan, Katy, 114, 117, 118
Howard Area Community Center, 117, 120
Howard Street, 2, 13, 57, 59, 61, 62, 66, 67, 69, 73, 74, 81, 87, 89, 91, 105, 106, 124
Howard Street Pageant, 66
Howard Station, 22, 47, 57
Howard Theater, 61, 69, 91
Indian Boundary Line, North, 11, 15, 23
James, Michael, 107, 114

Jarvis Avenue, 22
Kane, Mother Mary Isabella, 82
Kerns, John, 53
Kinsch family, 42, 43, 69
Kukla, Fran and Ollie Show, 86, 96
L service, 57, 106
Lakefront Protection Ordinance, 115
Lassen, Rabbi Abraham, 75
Leone Park and Beach, 115
Leone, Sam, 70, 71, 102, 115
Lost Boys of Sudan, 121
Loyola Park, 95
Loyola University Chicago, 10, 36, 37 51, 82, 84, 85
Loyola University Chicago Ramblers, 85, 107–109
Lunt Avenue, 17, 23, 35, 40, 60, 73, 75, 121
Madonna della Strada Chapel, 84
Marquette, Jacques, 10
McCann, Walter R., 24
Mertz, James J., SJ, 84
Metea, 15
Morse Avenue, 19, 50
Mundelein, Cardinal George William, 82
Mundelein College, 82, 83, 104, 106, 107, 112, 113, 118
Murphy farmhouse, 19
Nepper family, 42, 43, 69
Norshore Theatre, 61, 66, 67
North Chicago Street Railway Company, 30, 31
North Shore School, 119
Northwestern Elevated Railroad, 22, 57
Oaks, the, 20, 21
Oliff, Hershel, 78, 98
Orr, David, 117
Paschke, Ed, 124
Pollard, John William, 24, 46
Pollard, Luther, 40
Pollard, Frederick Douglass "Fritz" Sr., 46, 79, 86
Pollard, Frederick Douglass "Fritz" Jr., 40, 86
Potawatomi, 7, 9, 10–13, 16, 125
Pratt Boulevard, 65, 75, 88, 102, 136
Pratt Boulevard Beach, 124
Prinz, Tobey, 100
Ravenswood Avenue, 17, 23, 24, 25, 26, 32
Ridge, the, 26, 27, 28
Ridge Boulevard, 8, 13, 39
Rogers Avenue, 11, 12, 15, 19, 23, 54, 74, 79, 122
Rogers Park Baseball Club, 52
Rogers Park Building and Land Company, 20
Rogers Park Community Action Network, 117, 123

Rogers Park Community Council, 105, 107, 111, 115
Rogers Park Congregational Church, 35
Rogers Park Fire Station, 32, 45
Rogers Park Hospital, 34
Rogers Park Life Saving Station, 53
Rogers Park Police Station, 32
Rogers Park Post Office, 33
Rogers Park Woman's Club, 51
Rogers, Philip McGregor, 7, 8, 11, 17, 19
Sampson family, 64, 72
Schmidt, Martin J., 94
Sheldon, Sidney, 77
Sheridan Road, 10, 50, 54, 55, 62, 68, 79, 92, 97, 111, 122
Sloan, Junius R., 2
St. Henry's Catholic Church, 26
St. Ignatius Catholic Church, 36, 103
St. Paul's Church by-the-Lake, 35
Steffens house, 54
Sullivan High School, 80, 81, 92, 99, 110
Takata, Lynn, 124
Tatz, Beverly, 75
Temple Mizpah, 75, 110
Thiry's Household Utilities, 63
Tillstrom, Burr, 77, 86, 95, 96
Tipp, Karen Wagner, 98
tollgate, North Clark Street, 23
Touhy, Catherine Rogers, 18, 20
Touhy, Patrick Leonard, 7, 17, 18, 20, 101
Touhy Avenue, 19, 52, 89, 115
Touhy Park, 101
Tres, Peter, 25
Weimeschkirch Undertaker, 34
West Ridge, 8, 27, 28, 42
Wheeler, Albert and Cassie, 50
Wilkins, Josephine, 40
Williams, Herbert, 79, 122
Winninger, Peter Charles, 93
Winninger, Peter Jr., 117, 119
Wright, Frank Lloyd, 54, 55
Zender, Catherine, 59
Zender, Cora Lee, 89
Zender, John "Jack," 59
Zender, John, 17, 18, 19, 59
Zender, Mary Lou, 89

DISCOVER THOUSANDS OF LOCAL HISTORY BOOKS FEATURING MILLIONS OF VINTAGE IMAGES

Arcadia Publishing, the leading local history publisher in the United States, is committed to making history accessible and meaningful through publishing books that celebrate and preserve the heritage of America's people and places.

Find more books like this at
www.arcadiapublishing.com

Search for your hometown history, your old stomping grounds, and even your favorite sports team.

Consistent with our mission to preserve history on a local level, this book was printed in South Carolina on American-made paper and manufactured entirely in the United States. Products carrying the accredited Forest Stewardship Council (FSC) label are printed on 100 percent FSC-certified paper.

MADE IN THE
USA